ART
in the
Humanities

PATRICK D. DELONG

PRENTICE-HALL, INC., *Englewood Cliffs, New Jersey*

PRENTICE-HALL INTERNATIONAL, INC., *London*
PRENTICE-HALL OF AUSTRALIA, PTY. LTD., *Sydney*
PRENTICE-HALL OF CANADA, LTD., *Toronto*
PRENTICE-HALL OF INDIA PRIVATE LIMITED, *New Delhi*
PRENTICE-HALL OF JAPAN, INC., *Tokyo*

TO MAXINE, MICHAEL, AND PATRICK

Acknowledgments I wish to give special thanks to Sol Rabinowitz, for his willingness to share some of his ideas about the life-affirming aspects of art, and to Thomas Mc-Elligott, for his steady help and advice as the manuscript grew.

CONTENTS

ART

in the

Humanities

Introduction

This book may be used as one of the textbooks in any Humanities program in which some emphasis is placed on looking at art in western civilization. It is not, however, an attempt to examine the various interpretations of man as they are revealed in the humanities. The program may also be of a historical-cultural survey type with this book serving as a guide to appreciation.

Since no amount of reading about art can take the place of actual visual experience, the student must, therefore, be given in class the opportunity to look at representative examples of significant paintings and pieces of sculpture.

The focus of this book is on "looking" at art. Just as music cannot be understood unless it is heard, art means nothing unless it is seen.

There is no way yet discovered to "teach" a person to "appreciate" art or anything else. It is, however, possible to help someone understand what is basically involved; appreciation must come later.

In this book, the emphasis is not on the history of art or on picture-composition. In keeping with the over-all emphasis on looking, the primary approach will be to consider those *psychological* factors essential to communication between the art spectator and the artist. Thus it is addressed to the reader who has yet to be initiated into the world of art, but who, on the other hand, will quickly realize that he has natural sensory and perceptive abilities which will enable him to become pleasurably involved in the art process.

CHAPTER ONE

How to Look at Art

THE DIFFERENCE BETWEEN FORM AND CONTENT

Most people do not know what to look for when they look at a work of art. For example, when they look at a painting they usually look for the story. By looking for the story alone, they miss the vital part of a painting: not the content or story but the form. The form is the real essence of the painting.

The story is the literal part of a work of art, whereas the form has to do with the style or the design. It is the style of the great artists as well as the style of the great civilizations that we most admire. For example, the Renaissance produced many statues of David (Fig. 1), but it is the one by Michelangelo that we remember. It is not the subject matter, "David," that makes Michelangelo's piece famous—it is the "form" of the work.

Michelangelo's *David* was no mere imitation of a youth. His David was a youth re-structured: a blend of the classical style with the individualized schematic style of Michelangelo—a youth re-structured to symbolize for Renaissance man the new spirit of his age. Similarly, in the ancient world there were hundreds of sculptural friezes but none to match those of the Parthenon (Fig. 2). It was the Greeks' use of form that made their work superior (Fig. 75).

Form makes the difference and we are most aware of form when it is recognizably different, as in oriental art. The oriental style is somewhat unappealing to us in the Western world because of its flat, decorative quality (Fig. 3). But because form has been traditionally stressed in oriental art, the people in Asia have been conditioned to look at art properly.

4

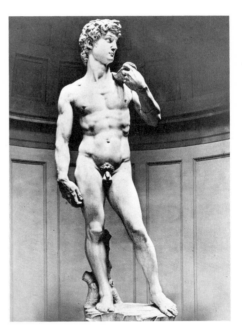

1. Michelangelo. *David*. 1501-
04. Marble, height 18′. Acad-
emy, Florence

2. The Parthenon, by Ictinus and Callicrates (view from the west),
448-432 B.C., Acropolis, Athens

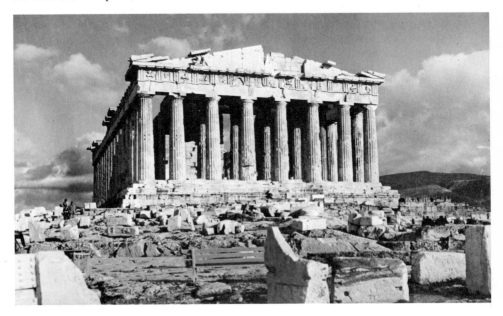

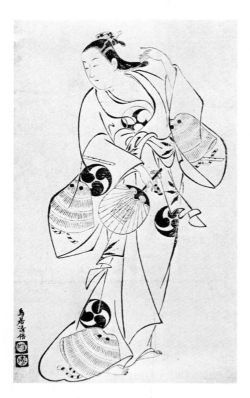

3. Torri Kiyomasu. *Woman Holding Comb*. Japanese, Edo Period, early 18th century. Woodcut. The Art Institute of Chicago (The Buckingham Collection)

For example, it is true that a sentence written in Chinese *means* something, because, if it is well written, it communicates an idea. But, in the Chinese case, more is communicated than just the conceptual idea: the written sentence becomes an arrangement of brush strokes made with artistic care. We call this calligraphy. And because the brush strokes happen to form a beautiful design, more is communicated than just the "story." In such cases the additional "message" is purely visual: it cannot be described fully with words. It is of a perceptual nature, that is, it has to do with "pure-seeing" as opposed to "story."

Likewise, a painting has two parts: *form* and *content*. If the viewer is capable of "getting" *only content,* one part, then *one half of the message* is lost and full communication does not take place, as the following diagram illustrates:

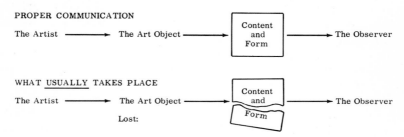

PROPER COMMUNICATION

The Artist ⟶ The Art Object ⟶ | Content and Form | ⟶ The Observer

WHAT USUALLY TAKES PLACE

The Artist ⟶ The Art Object ⟶ | Content and Form | ⟶ The Observer

Lost:

As you can see from the diagram, in order for a work of art to communicate fully it must be "seen" from the standpoint of both *form* and *content.* The person who looks for the story and ignores that part of the painting which is *purely visual* gets only part of the message: full communication simply does not take place. What makes this doubly unfortunate is that the important part is the *form*. In other words, the most *meaningful* part of a painting is most often the part that is ignored. Furthermore, if the visual design is inferior, it is not a good painting, regardless of the story. Unfortunately, "seeing" with the emphasis on "story" has been the artistic diet of most Americans. The imagery of our society has emphasized story.

The minute the average American looks at a painting he falls into the trap of looking for the story—and this alone. He can't be blamed altogether for making this mistake because this is what he has been taught to do; this has been a part of his miseducation in art. In spite of the fact that the vital part of the painting is the visual part, people have been so conditioned by our society that they are usually unable to read its message. How has the cultural conditioning of our society hampered us in our capacity to appreciate art?

For years, the art that reached the bulk of our society was consumer art—it became the great conditioner. This art emphasized pictures that were primarily literal in content: pictures that told stories. Furthermore, there was little form to these pictures; they were usually painted with virtually photographic realism—completely lacking in style.

That consumer art in this country evolved in this way is not difficult to understand. Considering the times, from the Gilded Age to the birth of Madison Avenue advertising, such a course, it seems, was inevitable. It was our tradition in America to be strongly influenced by European cultural trends. Consequently, we inherited the Victorian belief that art is the "imitation" or "copy" of nature. We inherited additional Victorian bric-a-brac as well: art was to be pretty, romantic, grand, or heroic. This was the sum of our artistic legacy. And, even more sadly, as an isolationist and somewhat provincial nation until the mid-thirties, we ignored the revolution in modern art that first began with the French Impressionists in the 1860's. In short, we missed the meaningful in European art and took to what time and history proved to be sop. Other aesthetic views typical of those days were: If it was made in Japan it was inferior, and if it came from Africa or Mexico it was crude. We were simply never taught that art could contain both form and content: design as well as story. Our parents measured most art by the "calendar painting" yardstick: paintings should be crowded with narration.

True, sophisticated young adults today are somewhat better off. But still, too often, our young people in school are being trained in the virtues of science and the space age with not enough time being given to a truly

functional approach to art. In many instances, parents and traditionalists in education think of art as a frill subject rather than a vital part of human living. In such an atmosphere, our young people tend to approach their work in the art classroom frivolously. Consequently, the results are seldom significant or satisfying.

THE IMPORTANCE OF FEELING

Another way of looking at art, other than just looking for the story, is to "look" from the standpoint of *feeling*. Of course, again, whatever kind of feeling-impact one gets is best carried by the form or the design rather than the story. The nuances of color and line have more to do with creating a mood than *any* story. To be able to enjoy such things as line, shape, color, and texture, is really the only way to benefit from whatever feeling the artist puts into his work. It is from his use of color and the action of his brush—not from the literalness of the wheat in the painting— that we know how Van Gogh felt about a harvest of wheat (Fig. 11).

THE PURELY VISUAL PAINTING

Since many modern paintings are purely visual (Fig. 4)—without any story or any identifiable objects—it becomes all the more difficult for the literal or story-oriented man to understand what is going on. He rejects such paintings by placing the blame on the artist: "He's some kind of a nut . . . painting a picture without 'anything' in it!" Yet, the same man

4. Jackson Pollock. *Number 32.* 1950. 9' × 15' 11½". Collection Kunst-sammlung Nordrhein-Westfallen, Düsseldorf, Germany

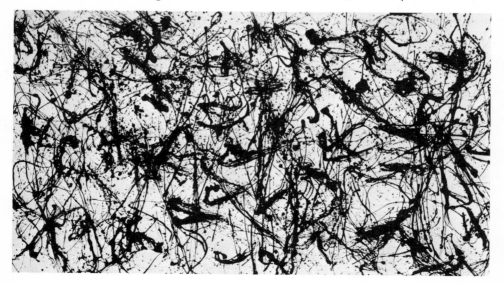

who rejects the non-objective painting may possibly like music—both classical and progressive jazz—*music without words!* Why is he tolerant about music and not about art? Again, possibly because the musical traditions that we inherited from Europe earlier were, for the most part, more meaningful. The music of Beethoven made some sense to those who cherished liberty above all; the foppish popular paintings of the bourgeoisie did not. Straight down the line, our tastes in music ran better, and as a result, we have been more tolerant toward music. For example, today, we accept abstract music but not abstract art. However, our concern at this point is not so much why music is appreciated and understood more easily by Americans than paintings and sculpture but what is required in order to be able to appreciate the visual arts.

THE ATTITUDE OF LOOKING

Besides knowing that art contains both form and content, in order to like it one must be *willing* to look at it! There is a proper way to do this. As André Malraux describes it, art is the silent language. Drums and horns do not call one's attention to it. Malraux calls art: "The voices of silence." [1]

To be willing to look at art, one must take the time. Art cannot be enjoyed from the expressway. Art requires a contemplative attitude on the part of the spectator. The rapid-pace living of today is, of course, not conducive to the kind of detachment that is required for aesthetic contemplation. Again, as in the case of our cultural inheritance, this is not a conspiracy planned by technicians, engineers, and scientists to defeat the artist. Rapid-pace living obviously happens to be one of the less desirable by-products of our culture. The fact that it hinders aesthetic contemplation simply means that the art spectator must be willing to put himself in the proper frame of mind as he views a work of art . . . if he expects to communicate with it. Furthermore, by taking the time to look at art, a fuller, richer understanding of life will be the reward. Through art one may share the "Greek Experience"; through art one may share with Rembrandt his love of mankind; and through art one may share with Mondrian his feelings about the modern city and modern music (Fig. 5). In this sense, the art spectator transcends the limitations of time and place.

Having an open mind is also important. If one comes equipped with a mind set against enjoying art, one is not going to enjoy it. Many people resist modern art in this way. They don't like it because they don't *want* to like it. This sort of attitude, coupled with the lack of apprecia-

[1] André Malraux, *The Voices of Silence,* trans. Stuart Gilbert (New York: Doubleday & Company, Inc., 1953).

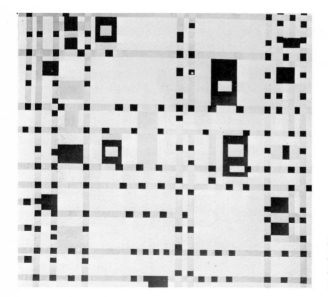

5. Piet Mondrian. *Broadway Boogie Woogie*. 1942-43. 50 × 50″. Museum of Modern Art, New York

tion for the "form" and "feeling" aspects of art, prevents many people from understanding and enjoying it.

The Qualifications for Understanding Art

There are additional problems that no amount of discussion or reading about art can cure. Some people are just not mentally or physically equipped to understand art on *all* of its various levels. Some works of art are more demanding intellectually than others, some require a greater feeling-reaction, some require the capacity to deal with symbols, and some require the ability to follow multi-level abstractions.

We shall discuss the symbolic and abstract aspects of art in later chapters, but since the ability of the spectator to think and to feel is involved in aesthetic communication, it is only fair that we spell out the major difficulties.

Because great art is often on a high intellectual level, appreciation demands the ability to think in philosophical depth. Furthermore, one must be knowledgeable. Because western art is so closely linked to history one must have a formal education to fully appreciate some of its aspects. This doesn't mean knowing names and dates and places in history, but it does mean knowing about some of the big ideas of the past and having some sense of history and human destiny.

The psychic conflict between Michelangelo's love of the church and his love of the pagan art of antiquity and the way it manifests itself in his work is an example in point (Fig. 1). Scholarly volumes are still being written about this man, his work, and his time—and how all of this is to be equated with our time. The work of Michelangelo is an education in itself. In art, intellectual aliveness is required on every hand, and espe-

cially in modern times. The multiple worlds of Picasso are not for those who are not curious about history, philosophy, psychology, science, and world affairs in general. His art is not for the indifferent.

In addition to intellectual aliveness, emotional aliveness is demanded. To "feel" art, one's sensory equipment must not be self-crippled. The harmony of structure in a work of art is felt primarily through our own bodily sensations: the way we move, the way we breathe, the way we are built. When we react to color in a painting, for example, we react in terms of body temperature. We describe color as being either warm or cool. Visceral associations are also made with color. In one situation, a certain color might be described as delectable; in another, as sickening.

In order to be sensitive to texture, one has to remove the gloves. Similarly, to feel volume, one has to be capable of taking a deep breath occasionally. The person who, for no rational reason, avoids the direct sunshine, does not like to stand in the wind, and is annoyed by the texture of gooey paint would, by necessity of temperament, reject the works of a painter such as Vincent Van Gogh. The person who avoids the sensual would reject the sculpture of Rodin and the person who does not like to move about would not appreciate the abstractions of Hans Hofmann. We are speaking here of the kind of person who armors himself to the extent that he avoids having full sensory contact with life. We wish to make it clear that we are not speaking of the person who, through no fault of his own, suffers from an organic disability. To put it another way, to be sensitive to art from the standpoint of feeling, a love of life is required. One must be, to a degree, what Erich Fromm describes as the biophilious character.[2] The opposite is what he calls the necrophilious character, or the character type that is fascinated by everything that is orderly, still, static and non-moving—by everything that is not alive. To put it most bluntly, an Eichmann could not communicate physiologically with Rembrandt's *Descent from the Cross* (Fig. 6). Nor could a Hitler or a Stalin perceive physiologically and grasp the feelings expressed in Picasso's *Guernica* (Fig. 7), a mural depicting the bombing of the civilian population of a town during the Spanish Civil War. Such life-negating and mechanistically structured men as these feel threatened by works of art which are searching, courageous, and truthful in content, and which, most importantly, radiate these feelings through the energetic and creative manifestation of form.

A total physiological aliveness and contact with life does not mean that the art spectator should drool when contemplating a painting of roast beef in the cooking section of the *Ladies Home Journal*. For the same reason, seeing a Brigitte Bardot movie has nothing in common with "seeing" the Venus de Milo. Aliveness to art is not simply a manifestation

[2] Erich Fromm, *The Heart of Man* (New York: Harper & Row, Publishers, 1964), p. 39.

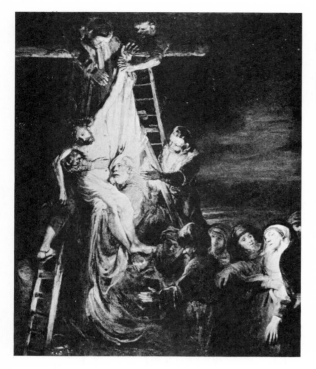

6. Rembrandt. *Descent from the Cross* (detail). 1650-51. National Gallery of Art, Washington, D.C. (Widener Collection)

of the autonomic nervous system. It is not a matter of drinking in or gourmandizing. The mind and senses are involved but in a detached way. By looking at a work of art we are not psycho-physically excited, but we are spiritually enriched as we come to grips with it. For example, when we see a sketch by Rembrandt or Delacroix we are psychically energized by the sense of movement inherent in the line but only in the sense that we are thrilled by its quality. It must be realized that art is in the realm of contemplation—a realm apart from the world of actuality. If it is art, it is energizing also in that it is in some way refining, or life-enhancing. Mind and senses are involved but what sensations there are are *idealized* rather than actual. It is in this sense that one needs to differentiate between those sensations that are evoked by art and belong to the imagination and those that belong to the world of reality.

Notice that as we have discussed some of the problems of looking at art—not looking for just the story, being open-minded, taking the time to look properly, and being fully alive physiologically—we have cited difficulties that have to do with one's psychological make-up. In essence, the psychological make-up of the viewer is the determining factor. Frankly, art is not for the dull, the insensitive and the destructive; it is not for morons, gluttons, or destroyers of life. People who are rigidly closed minded

and dogmatic about what art is supposed to be are also at a disadvantage as viewers of art. On the other hand, people who are intellectually alive, who are open-minded and who are capable of responding to the kind of sensory stimulus that accompanies art have an advantage as spectators. And fortunately, in this regard, there are many people who can be helped when it comes to understanding art. Once they know what the problems are, rapid progress can be made.

The Responsibilities of the Artist

So far, we have been concerned only with the responsibilities of the spectator. What about the artist? As a producer of art, does he have any responsibilities? Most certainly he does. And some of the confusion that surrounds contemporary art may be laid directly at his feet.

First of all, for any work of art to be of significance, the artist must have something to say. In addition, he must have the technical skill to get his message across. He must know what to say, how to say it, and be capable of saying it. This is no easy task. Serious art is serious business. Because a man calls himself an artist is no guarantee that he is one. Because a dealer promotes an artist's work is no further guarantee. Today, especially, dealing in art is also a big business. And because the public is unfortunately gullible when it comes to art, much that is passed along has no more significance than last year's society headlines. As many sociologists have pointed out, there are big rackets and little rackets in contemporary American society. In the art game, as in every walk of life,

7. Pablo Picasso. Guernica. 1937. 11′ 6″ × 25′ 8″. The Museum of Modern Art, New York (On indefinite loan from the artist)

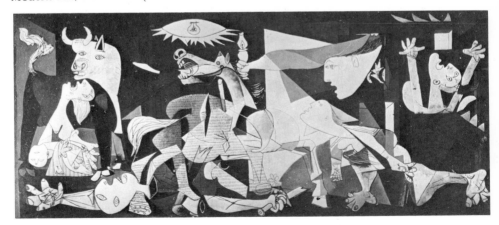

people are manipulated by those who seek prestige, power, or cash and there is no shortage of irresponsible manipulators. If you can find a racketeer in industry, politics, or religion, you can find one in a garret or a gallery.

Often, throughout the past, what has been acclaimed as the significant art of the day has later been labeled as fad, fallacy, or fakery. A roll call of the popular and wealthy painters of the Victorian Age would contain only a few names that we would recognize today. Our time is no different. Simply because a man would like to make a profound painting is no indication that he will be successful. Skill of execution (technical skill) is not easily mastered. Usually it takes years for an artist to develop. El Greco, Rembrandt, and Cezanne, like most great artists, became truly great only in their late years. Proper communication in art requires competence and hard work on the part of the artist.

CHAPTER TWO

Art and the Imitation of Nature

Since, for most of us, education in art has been a sort of willy-nilly moving along without anyone to guide us or caution us against overexposure to the prevailing calendar art concepts of our culture, we have become susceptible to some very biased views as to what art is supposed to be. We have cultivated a peculiar crop of misconceptions about the role of art and the artist in society. Frankly, we have acquired some prejudices that are nothing short of absurd. With the hope of improving communication between the artist and the average person, let us examine these prejudices. First among them is the idea that art is an attempt to imitate or copy nature.

Art is *not* an attempt to imitate or copy nature. When we study the great art of the various civilizations as well as the individual styles of some of the great artists of the past this becomes especially apparent—even though it contradicts what some of these same artists *said* they were doing.

For instance, Leonardo da Vinci, in his treatise on painting, gave many instructions to the art student that contradict what he did on canvas. It was da Vinci who wrote, "that painting is most praiseworthy which is most like the thing represented." Yet, this was a man whose landscape backgrounds for his *Mona Lisa* (Fig. 8) and his *Madonna of the Rocks* are unlike anything in reality. (Today, we can describe these backgrounds as surrealistic.) Nor were the faces in these paintings real. In both paintings, the faces are idealized along classical lines; they are more like the faces on Greek sculpture than those found on human beings.

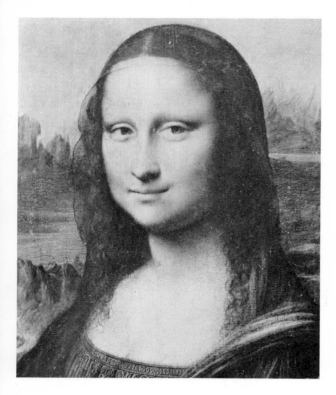

8. Leonardo Da Vinci. *Mona Lisa*. c. 1503-05. Panel, 30¼ × 21″. The Louvre, Paris

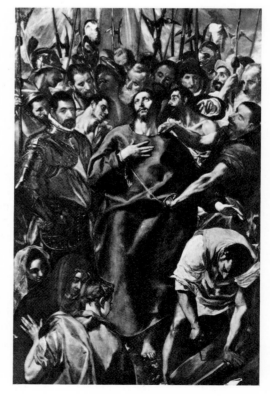

9. El Greco. *The Disrobing of Christ*. 1579? Cathedral, Toledo, Spain

Michelangelo created giants on his Sistine Ceiling rather than men. Rembrandt used lighting effects that resemble those achieved by high-powered electrical spotlights rather than any light found in nature—long before the invention of the light bulb (Fig. 6). And, if we look closely at Rembrandt's portraits, we realize that every face Rembrandt painted was his own. El Greco's elongated figures are quite unique (Fig. 9), and Cézanne's space belongs to a world with dimensions other than ours. Try standing as the figure in an Egyptian wall painting stands, and try to throw a discus in the manner of the Greek "Discobolus" (Fig. 10). The cypress trees (Fig. 11) painted by Van Gogh grow faster, than any found in nature, and Turner's ships sink more slowly (Fig. 12). The world of each artist mentioned is a special world, a private world, a world abstracted from ours. Where did we get the idea that art was supposed to be an imitation of nature?

To begin with our own time, most advertising artists are expected to make extensive use of the camera. As a result, the public has become visually indoctrinated and conditioned to a particular style of slick, photographic realism. This so-called slick, commercial style of magazine and billboard advertising art has evolved over the past thirty years to the extent that, often, the commercial artist's job depends upon his willing-

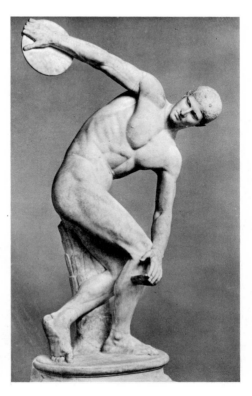

10. *Discobolus (Discus Throw-er)*. Roman marble copy after a bronze original of c. 450 B.C. by Myron. Lifesize. Museo delle Terme, Rome

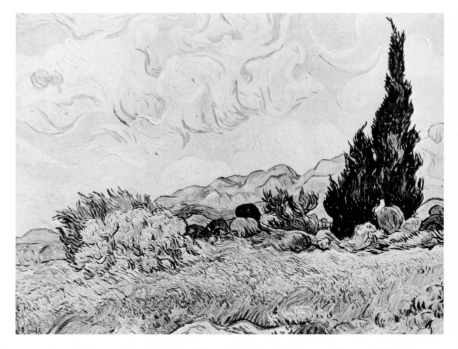

11. Vincent Van Gogh. *Wheat Field and Cypress Trees*. 1889. Canvas, 28½ × 36″. The National Gallery, London (Reproduced by courtesy of the Trustees)

12. Joseph Mallord William Turner. *The Slave Ship*. 1839. Canvas, 35¾ × 48″. Museum of Fine Arts, Boston

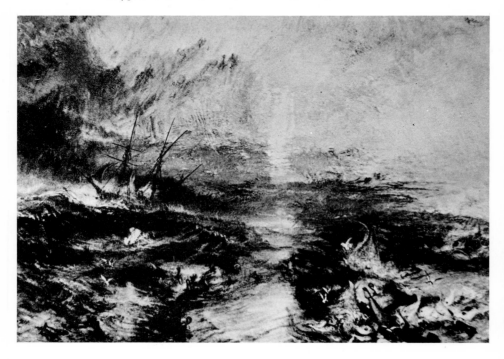

ness to render things in an antiseptically slick and photographic manner. What is unfortunate here is the fact that a great majority of the public confuses the goals of such commercial artists with the goals of the fine artist.

As a recent development, in the area of story illustration, commercial artists have been demanding more artistic freedom. Because of this fortunate trend, magazine illustrations are becoming much more creative than they were a decade ago, and more and more fine artists are being asked to make illustrations. Today, we see fewer photographically interpreted faces on the cover of *Time Magazine* and more painterly ones.

Nevertheless, after more than a generation, slick photographic realism has left its impression on our visual tastes. In this vein, paradoxically, it is interesting to point out that, by falling back on the negative aspects of advertising art, the Pop artist is actually saying something positive. Supposedly, Pop art stands for what is popular—at least, this is implied by the label. But by openly and satirically embracing commercial realism, the Pop artist makes us conscious of the shallowness, the toughness, and the crude and dehumanizing aspects of such realism. Thus, in a way, Pop art becomes an art of protest—protest against popular tastes.

Most of the people of our generation who insist that it is the artist's task to copy nature have acquired such a conviction primarily because they have been visually conditioned by the commercial realism we have been speaking of. But, in all frankness, this belief has also been with us historically, on and off, since the time of the Greeks. The fact that it is founded mostly on half-truths and a superficial acquaintance with the styles of the great artists of Western civilization makes little difference to most people. For example, if we consider Greek philosophy, this misconception was fostered by the way in which Aristotle was interpreted when he wrote about art as "the imitation of nature." He did not mean this literally but, as is often the case, his words were misconstrued. To Aristotle, according to his *Poetics*, the purpose of art is to capture the essential form of things. He did not consider art to be a mechanical copy of nature. Aristotle clarified his remarks by such phrases as, "to depict the hidden meaning of things, not their appearance . . ." and, ". . . the secret of things which is not in their appearance . . ."

However, not the essence of Aristotle's thought but the popular opinions about what he meant are the things we have had to live with. As a Greek philosopher, his remarks were bunched together with the popular stories told about the skills of Greek painters by succeeding chroniclers. As a part of the folklore about their skills—and because of the dampness of the Mediterranean climate there is little left to go by except folklore—it was said that in their murals the grapes were painted so well that the birds tried to peck at them. Yet, when we disregard these stories about the Greek painters and look at the few examples of Greek painting available—on Greek pottery—we find that they are primarily

linear and flat. Certainly, feelings of life and movement are skillfully covered and the depiction of anatomical structure is remarkable, but the drawing style relates decoratively to the surface of the vase rather than imitatively to reality (Fig. 13). And when we view the sculpture of the Greeks, especially those statues made in the Severe Style (Fig. 10), we are again moved by the form—not as it imitates reality but as it depicts the Greek style. What we admire in these harmoniously proportioned figures is not their imitative qualities but their idealized qualities. They are serene, graceful, quietly balanced, and, as a consequence, removed from reality. The overwhelming sense of timelessness that is conveyed by such work is due to the Greek artist's ability to transcend reality.

As the Roman world succeeded and took over from the Greek, art did become, for a time, quite imitative. For the most part, the art produced by the practical and materialistically minded Romans was an art of ingenious realism. The Romans were great admirers of Greek art but they failed to understand its intrinsic meaning. Roman sculptors depicted their most popular subjects, soldiers, gladiators and statesmen, in a starkly realistic manner, with little concern for style. As a result, we have Roman records in marble of this or that imperial event but seldom anything creatively envisioned by an artist. The visual confusion of the Column of Trajan (Fig. 14) is not to be equated with the compositional harmony of a Parthenon frieze. As the Roman artist turned more and more to the real, he functioned less and less as an artist. Too often, what has been preserved by history are the artifacts of Rome rather than objects to be cherished as works of art.

With the decline of Roman civilization there was, beyond a doubt, a corresponding decline in realism. The artists of the Byzantine civilization in the Eastern Mediterranean and its counterpart in the West, were not concerned with making copies of the real world in any sense. Early Christian art had as its goals values that had little to do with this world. The spiritual mysticism of Christian art called for an anti-representational, abstract, and symbolic style. With the Byzantine (Fig. 15) and Gothic (Fig. 16), for example, we see two distinctly formalized styles—styles that are otherworldly and severe. Just as the art of Egypt was a reflection of the ideas and values of a society that was intensely proud of its permanence, of its priest-king hierarchy, and of its religion which emphasized the world of the dead, so too did the art of the Middle Ages reflect the spiritual and philosophical values of the Medieval Christian civilization. But whereas Early Christian art turned away from realism, Christian art of the Late Middle-Ages, with the revival of humanism, turned toward it again.

In the new church art of the Renaissance, such religious symbols as the halo gradually disappeared. Depth in space was suggested and eventually, with the invention of perspective, fully developed landscapes

13. The Achilles Painter. Detail of an Attic white-ground lekythos. c. 440-430 B.C. Private collection

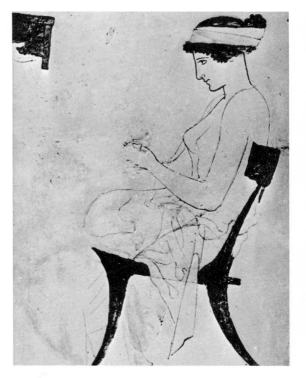

14. Lower Portion of the Column of Trajan, Rome. 106-113 A.D. Marble, height of relief band c. 50″

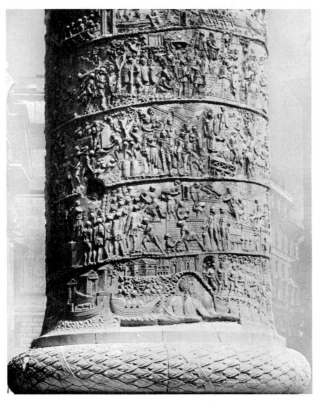

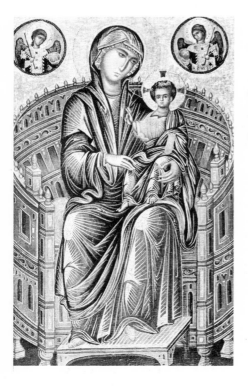

15. *Madonna Enthroned.* 13th century. Panel, 32 × 19½". National Gallery of Art, Washington, D.C. (Mellon Collection)

16. Jamb Statues, West Portals, Chartres Cathedral

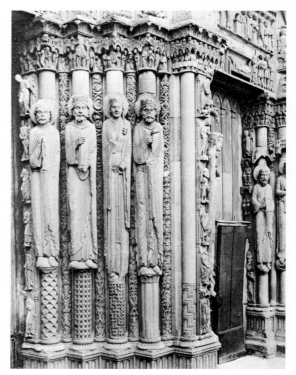

were to emerge. Along with perspective in drawing, the technique of chiaroscuro, or soft shading, was developed. Soft blending techniques were also developed in painting—due to the change-over in mediums from egg-tempera to oil—and edges and outlines became less apparent. True, as the worldly superseded the other-worldly in Renaissance thought, the same trend followed in its art. But, as we have stressed earlier, the comparative realism of such Renaissance greats as Leonardo and Michelangelo is not to be equated with the realism that the camera records.

During the late Renaissance and the Baroque period and within the many traditions that followed, such as rococo, neo-classic, romantic and genre, we find that artists were concerned with painting virtually all aspects of the real world. But, with few exceptions, we also find that the best of these artists were either imaginative, visionary, intimate, whimsical, lyrical or poetic rather than exact, precise, accurate, factual, and realistic. The highly individual styles of such artists as Latour, El Greco, Titian, Tintoretto, Rubens, Hals, and Delacroix do more than simply correspond to the actual in nature. There is more to Dürer than detail, more to Holbein than preciseness, more to Caravaggio than factualness, and more to Vermeer than realism.

Unfortunately, however, once equipped with the techniques of perspective and chiaroscuro, artists lacking in individuality and poetic spirit became the victims of these techniques. For the less creative, the feat of creating the illusion of three-dimensional reality on a flat surface became a goal in itself. In such illusionist art, the tricks of the trade involved painting objects such as musical instruments, books, jewelry, and so forth, as though they were actually resting on real shelves or hanging from actual walls. Often, the transition between the real and unreal became playfully ludicrous. For example, as the illusionists gathered full-steam with their "fool the eye" or *trompe-l'oeil* effects, it became fashionable for the wealthy to have their mansions built with pillars and doorways painted on the walls. Pretty little girls (also painted) would often be seen passing through these doors; it was all very cute and very "real" in an unreal sort of way.

Such trivial and literal work was produced by artists who were too absorbed in technique, or were trying to be artful. It was not the work of artists who press on because of an inner drive to express their feelings about life. In the process of painting the Sistine Ceiling, Michelangelo found his style: His highly stylized figures were not preconceived but emerged as he became absorbed in his task. In order to paint his greatest portraits, Rembrandt had to first abandon the conventional techniques of portraiture. Neither was Van Gogh's varied brush-stroke something that was handed to him by the academicians of his time (Fig. 17).

Unfortunately, perhaps because the dexterity of an artist seems somewhat magical to the average person, the ability to render things

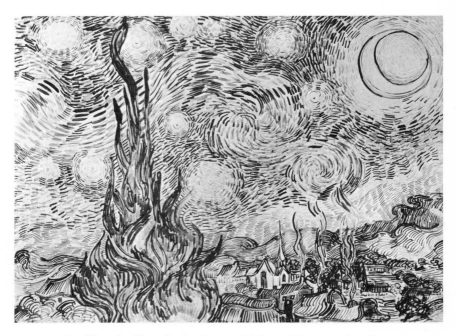

17. Vincent Van Gogh. *Starry Night*. 1889. Pen drawing. Formerly Kunsthalle, Bremen (destroyed?)

realistically and to record detail after detail is mistakenly equated with talent. Of course, the person who takes the time to become acquainted with the art that has endured will find that the measure of such art has to do with qualities that go beyond mere fidelity to nature.

As the tastes of the landed aristocracy tended to center on representational illusionism and finish, the tastes of the new bourgeois centered on an almost equally bad type of art. After the French Revolution, the art invented for the newly emerging middle-class was again representational and far more steeped in content. The rightful name for such furniture or paintings is "potboiler." Gathering dust in attics and cellars throughout Europe are hundreds and hundreds of paintings and pieces of sculpture that abound in realistic detail, that tell stories, that are pretty or sensational, but that are also purposefully forgotten. The insignificance of such literalness becomes apparent in time. In this sense, time is not only the judge of what is to be enduring in art, but also the executioner of art that is lacking in vision and quality. Unfortunately, art of this type is with us still—if not on our living-room walls then certainly on our calendars and greeting cards.

Without a great deal of searching we can still find about us the gallant knight with his Holy Grail, the heroic general on his white horse, the daring captain at the helm, the illustrious surgeon in the operating room, the horse and jockey with their victory wreath, and the lonesome cowboy on the trail. Of course, there is nothing wrong with the topics

themselves. A cowboy painted by Frederick Remington, a soldier by Andrew Wyeth, a sailing ship by Albert Ryder (Fig. 18), a child by Gauguin, and a clown by Rouault can be works of art. But paintings by artists such as these are memorable because of their form, not just their content. On the other hand, the popularity of the usual representational and "finished" painting is due to its capacity to involve our minds in the story, rather than our eyes and other senses with the feeling and the form.

With our bounty of advertising art added to this mixture of pot-boiling nostalgia, it may truly be surmised that the flies have abandoned the grapes and are now sampling the "air-brushed" frosty drops of moisture on billboard size beer cans.

The great artists of the past have never tried to copy or imitate nature. What they have tried to do is to make a visual translation of nature—something quite different. Because a canvas is not a picture window into nature the artist cannot put everything in nature into his picture. He can't even *really* put one thing of nature into it because a painting of a thing, no matter how realistically rendered, is not *the thing itself*.

18. Albert Pinkham Ryder. *Moonlight Marine*. Oil on wood, 11⅜ × 12″. The Metropolitan Museum of Art, New York (Samuel D. Lee Fund, 1934)

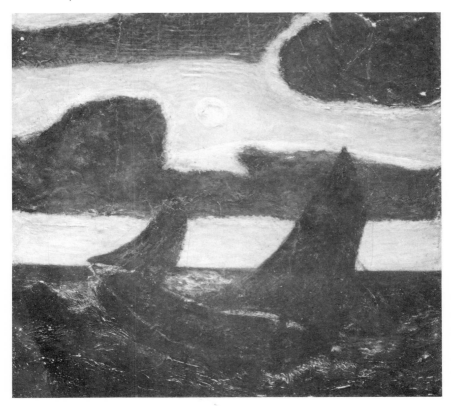

By necessity, the artist abstracts. He emphasizes some qualities by putting them in and de-emphasizes some qualities by leaving them out. He selects and simplifies. He transforms nature. It is his job to tell you how he *feels* about nature. In this sense, art is the language of feeling. The artist does not see nature in the sense that the driver sees the road. It is not the business of the artist to see in this everyday sense at all.

The artist sees in terms of his personal style or life-view. He sees in terms of what something in nature can *become* in his painting—as he imagines it. Thus, Rembrandt's *Night Watch* is not really a night scene nor is Henry Moore's *Recumbent Figure* a figure in the realistic sense (Fig. 19). Rouault's *Head of Christ* (Fig. 20) is *his* invention, fashioned after his view of life, and Michelangelo's *Last Judgment* (Fig. 21) *his*, fashioned after his view of death. Monet's famous *Impression of a Sunset* is his impression and his alone. Any one of Van Gogh's paintings of shoes are shoes worn by his soul rather than his feet: they tell us how he feels about human toil and misery rather than about shoes as such.

Whereas common sense tells us that no artist can duplicate nature, it is true that some works of art come closer to duplicating reality than others. Realism is a matter of degree just as abstraction is. Picasso's *Girl Before a Mirror* (Fig. 22), a cubist painting, is obviously more abstract than Wyeth's *Christina's World* (Fig. 23), a realistic painting. Wyeth puts in more detail than Picasso, but Wyeth's view of the world is as uniquely personal as Picasso's, although the artists' styles are most divergent.

19. Henry Moore. *Recumbent Figure*. 1938. Green Hornton stone, length c. 54". The Tate Gallery, London

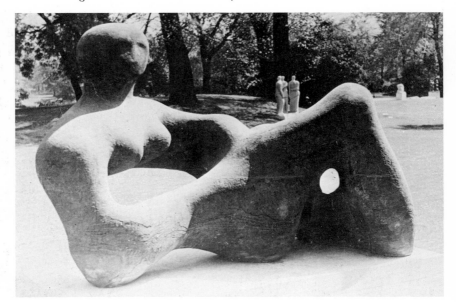

20. Georges Roualt. *Head of Christ*. 1905. Oil on paper, mounted on canvas, 45 × 31″. Collection Walter P. Chrysler, Jr., New York

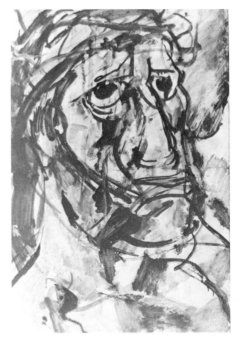

22. Pablo Picasso, *Girl before a Mirror*. March 1932. Oil on canvas, 63¾ × 51¼″. Collection, The Museum of Modern Art, New York (Gift of Mrs. Simon Guggenheim)

21. Michelangelo. *The Last Judgment* (detail, with self-portrait). 1534-41

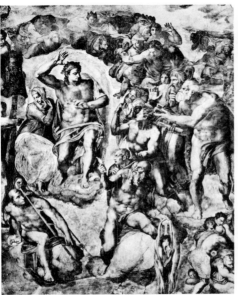

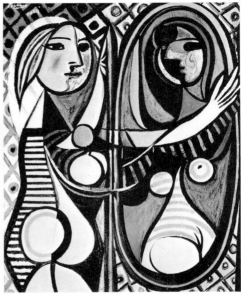

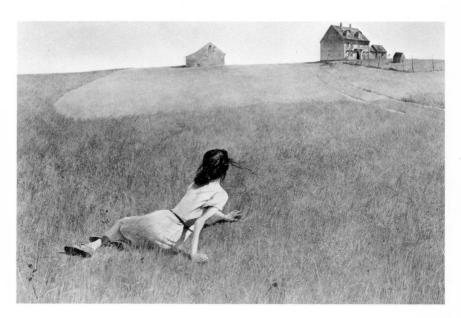

23. Andrew Wyeth. *Christina's World*. 1948. Tempera on gesso panel, 32¼ × 47¾". Collection, The Museum of Modern Art, New York (Purchase)

Their philosophies also differ. Picasso's interpretation of movement in his painting is relativistic or based on multiple images, compared to Wyeth's static or fixed view of a scene. By painting the girl's head in both profile and full-face, he offers two views of the girl at the same time. Naturally, this is a new visual interpretation of reality. But, since in life we perceive things in flux rather than from one static view, it corresponds to our twentieth-century understanding of reality. By introducing a sequence in time in this new way, a relationship to Einstein's space-time continuum is suggested. Multiple images, designed to create a feeling of movement or a sequence in time, were introduced in art during the time that Einstein's space-time-matter concepts were revolutionizing the scientific world. The art community, being more literate than most people credit it with being, caught this immediately. A new life-view was introduced by Einstein and, since the art of every age is a reflection of that age, the life-view of many artists was also modified. Thus, Picasso's *Girl Before a Mirror* becomes a modern translation of what life is all about—a translation of nature appropriate for man in the first half of the twentieth century.

In conclusion, if the reader has a traditionally-minded friend who keeps insisting that art is supposed to be an imitation or copy of nature, a possible way of re-convincing him would be to ask him if he thinks that Einstein's "picture" of nature is real enough. But a word to the wise: if he does not think so, don't argue the point.

CHAPTER THREE

Art and the Beautiful

Many people are of the opinion that it is the purpose of the artist to create works of art that are beautiful. Such an opinion is founded on the assumption that there is a common standard of beauty upon which artists may agree. Further, it is taken for granted that artists love beauty, that it is the beautiful in nature which inspires them. But the person who insists on one standard of beauty in art has never seriously looked at art. A close examination of the works of such artists as Bosch (Fig. 24), Michelangelo, Goya (Fig. 25), Daumier (Fig. 26), Lautrec, Rouault (Fig. 20), and Picasso (Fig. 7), to name a very few, would indicate otherwise. Moreover, those who insist that art and the beautiful are one, have simply overlooked a few major movements, such as the Assyrian, the Egyptian (Fig. 27), the Byzantine, the Gothic, the African (Fig. 28), the Indian (Fig. 29), and Oceanic (Fig. 30); and more recently, Expressionism (Fig. 31), Cubism, Surrealism, and Abstract Expressionism (Fig. 4).

On the other side of the coin, considering man's total historical past, what is left is, primarily, the classical tradition and its various offshoots; the Renaissance (Fig. 8) and Baroque (Fig. 32); Rococo, Neo-classicism (Fig. 33), Romanticism, and Naturalism. Along with classical art, it is these movements that have a direct bearing on our convictions about the good and the beautiful in art. Even, in consideration of this, it must be remembered that neo-classicism, which was ushered in by the political and philosophical goals of the French Revolution, was a revolt against the rococo style and that the romanticists disagreed violently with the neo-classicists. Furthermore, by the people who insisted that art is the creation of the beautiful, even Impressionism (Fig. 34), when it first appeared, was considered to be insultingly ugly. That Impressionism is not

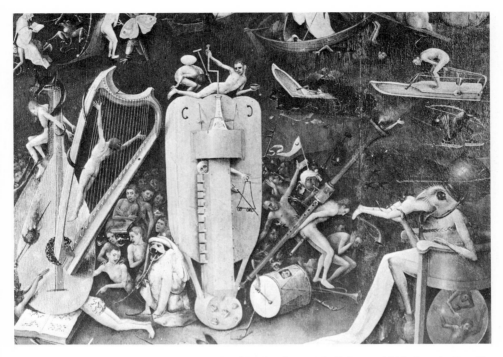

24. Hieronymus Bosch. *The Garden of Delights.* c. 1500. Panel (detail). The Prado, Madrid

25. Francisco Goya. *Bobabilicon* (*Los Proverbios,* No. 4). c. 1818. Etching. The Metropolitan Museum of Art, New York (Dick Fund, 1931)

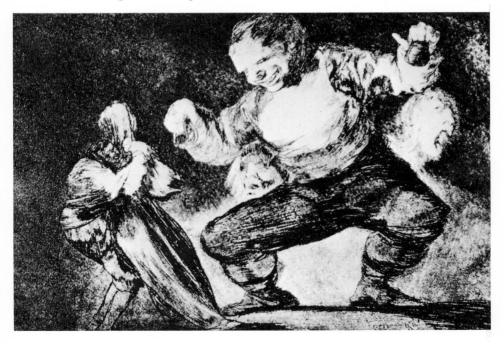

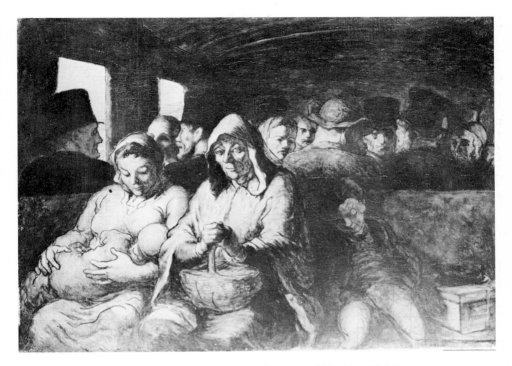

26. Honoré Daumier. *The Third-Class Carriage*. c. 1862. 26× 35½″.
The Metropolitan Museum of Art, New York (Bequest of Mrs. H. O.
Havemeyer, 1929. The H. O. Havemeyer Collection)

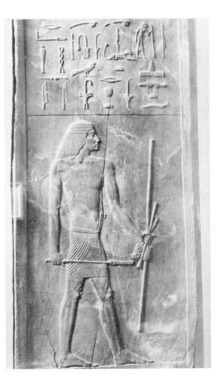

27. Portrait Panel of Hesire,
from Saqqara. c. 2750 B.C.
Wood, height 45″. Egyptian
Museum, Cairo

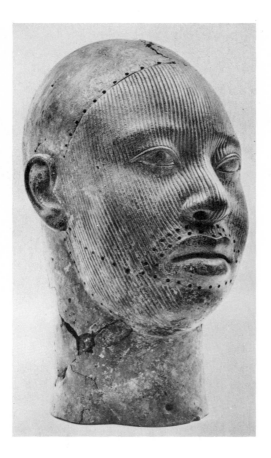

28. Male Portait from Ife, Nigeria. 12th century. Bronze, height 13½". Collection the Oni of Ife

29. *Lightning Snake, Wolf, and Thunder Bird on Killer Whale* (Nootka). c. 1850. Wood, 5' 8" × 9' 10". The American Museum of Natural History, New York

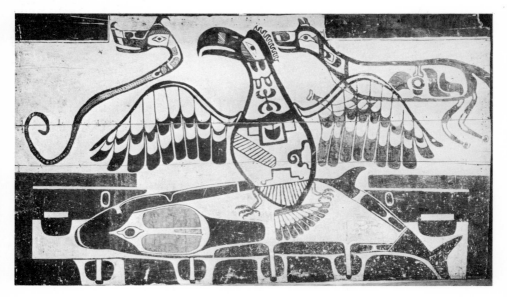

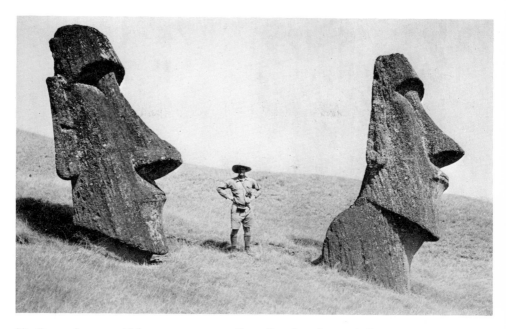

30. Stone Images. 17th century or earlier. On the slope of Ranu Raraku, Easter Island

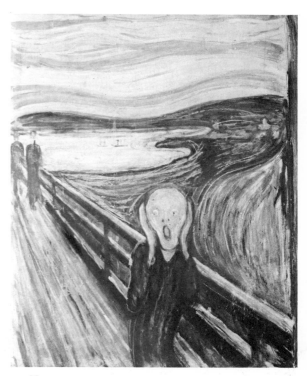

31. Edvard Munch. *The Scream*. 1893. 36 × 29″. National Museum, Oslo

33

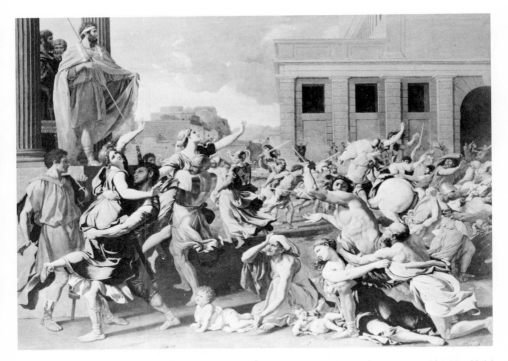

32. Nicolas Poussin. *The Rape of the Sabine Women*. c. 1636-37. 61 × 82½". The Metropolitan Museum of Art, New York (Dick Fund, 1946)

33. Jacques Louis David. *The Death of Socrates*. 1787. 59 × 78". The Metropolitan Museum of Art, New York (Wolfe Fund, 1931)

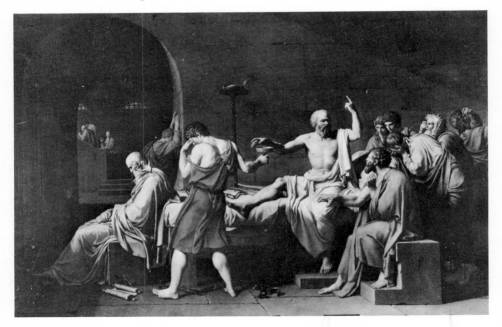

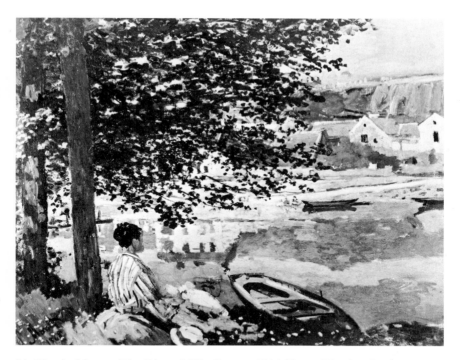

34. Claude Monet. *The River,* 1868. Canvas, 32 × 39½". The Art Institute of Chicago (Potter Palmer Collection)

considered to be ugly *today* brings up a point: opinions about beauty change over a period of time and vary from place to place.

Thus, a rational examination of the art of the past would force one to conclude that beauty is a variable or relative thing, yet some people militantly insist otherwise. To say that ignorance is the sole cause of such views is unfair. The causes are many and diverse; nevertheless, the main path of conditioning, in regard to this question of the beautiful, can be traced.

Being accustomed to the indoctrination of Victorian culture, most of our grandparents held the belief that the role of the artist was to depict the beautiful. Middle-class parlors from the Gilded Age through the early twenties contained paintings that were meant only to please—never to disturb. In spite of the sweat shops of the Industrial Revolution and finally the disastrous First World War, it was an age that thrived on a brand of art depicting elegance, grace, sweetness, virtue, nobility, and "the wonders of nature."

Let us describe a typical parlor painting of the time by Maxfield Parrish. Rendered photographically but in soft blues, it contained a nymph of a girl leaning against a Grecian column near an elegant pool. This simple setting had a theatrical backdrop of wondrous mountains. Today, many would consider it silly because of its artificiality and sweetness, not to mention the annoying photographic stiffness of the rendering,

but others would insist that its "truly beautiful" qualities are what is needed in art as never before.

Those good old days made room for other kinds of paintings: elegant or luscious still lifes of flowers or fruit, cherub-like children by the seashore or floating on clouds, heroes from Greek mythology idling in lyrical glades, Gibson Girl beauties, old millponds, and heroic generals marching their troops.

The people who insist that art should be an imitation of nature actually have in mind the particular brands of beauty just described. It isn't nature or reality that they are concerned with; they are concerned with preserving these artificial and stereotyped views of art and life. It should come as no surprise to find as staunch fundamentalists in art as in religion or politics. Such people insist that the artist who does not paint the beautiful is not an artist. Of course, they are referring to that old-time brand of beauty that resembles either the hand-tinted photograph or the sweet Victorian styles just described.

With the passing of time and the well-clad Gibson Girls and straight-laced Colonel Blimps, it becomes obvious that what one calls beauty is relative. Times change, tastes change, and attitudes about life and art change. And, as most people are aware, in a world that has grown smaller very rapidly, attitudes about beauty and taste are often conditioned by

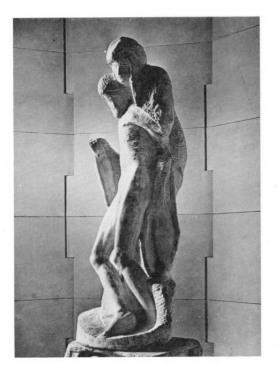

35. Michelangelo. *Pietà Rondanini.* c. 1555-64. Marble, height 77½". Castello Sforzesco, Milan

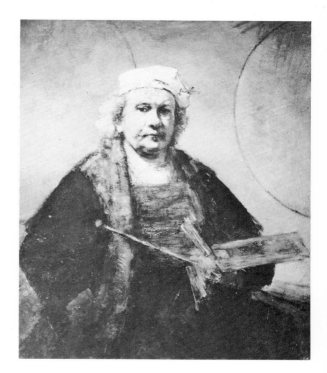

36. Rembrandt. *Self-Portrait.*
c. 1660. 45 × 38". The Iveagh
Bequest, Kenwood, London

one's locale as well as one's educational background. *One's total cultural environment* becomes the conditioning factor. The Indians who traded their gold for Columbus' beads were happy to do so; for their purposes, colored beads were as valuable as gold. But it was gold that the Spaniards valued—for reasons that were incomprehensible to the Indians.

In addition to environmental influences, concepts of beauty are often relative to the individual. In some ways, our ideas about beauty are quite personal. Some men prefer dark-haired women and some light; some people find a running sea invigorating and voyagers sometimes find it sickening. Furthermore, over the years, an individual's concept of beauty changes as he changes. Children are fascinated by things in nature that are often overlooked and ignored by their elders. Young people find a great deal of physical beauty in each other. Most older people find beauty of a different sort in their children. They often have a new appreciation for the simpler things in life that younger people seem unaware of. And so it goes.

In regard to such matters as beauty in life the artist often functions as a teacher. He can remind young and old alike of many special kinds of beauty (provided they take the time to look). Michelangelo's *Pietà* (Fig. 35), Rembrandt's self portrait (Fig. 36), Van Gogh's chair, a Surrealistic landscape by de Chirico (Fig. 37), a seascape by Homer, a sunset by Turner (Fig. 12), and a composition by Mondrian (Fig. 5), all tell us something different about life with each painting speaking of a different

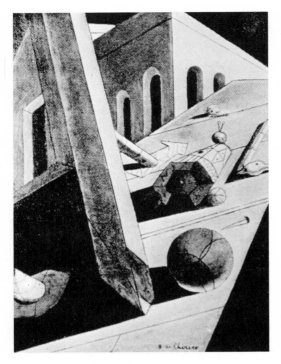

37. Giorgio De Chirico. *The Evil Genius of a King (Toys of a Prince)*. 1914-15. Museum of Modern Art, New York (Purchase)

kind of beauty. The artist teaches us to see, but through different eyes. Enriched by the personal interpretations of many individualized artists, our understandings of the the beautiful may be multi-valued and multi-leveled.

Even the celebrated art critics of the past would have to revise their theories about beauty in the light of today's knowledge of art. In Europe, until the nineteenth century, the view of most art critics as well as artists was limited to what was close to home. Gallery tours were the exception, and when conducted, limited to only nearby countries. Oriental, African, Oceanic, and Pre-Columbian American art was virtually unknown.

When we consider nineteenth-century art in Europe and America we must realize that it was, for the most part, based on certain rather fixed ideas about beauty. The norm for beauty in art was inherited from the Greeks. The idea of art as an attempt to depict the beautiful originates with them, yet no Greek would have admired the popular art of the nineteenth century. Form was stressed in Greek art rather than representational realism. Where content was involved it was timeless rather than momentary. The dignity of the Parthenon (Fig. 2), with its relief sculpture, was not founded on the sentimental, the prosaic, or the corny. Its voice was the voice of restraint, calmness, and serenity. It was the visual personification of the idealism of the Greek civilization. To consider such art analogous to the official salon art of the nineteenth century would be most undiscerning.

The Greeks were the first to dedicate their art to the beauty of life.
The art of earlier civilizations was subservient to the gods. For example,
Egyptian life and art were at the service of a politico-religious system
which was aristocratic and unyielding. This priest-king-god syndrome
kept everything focused on itself, and the people contentedly went along

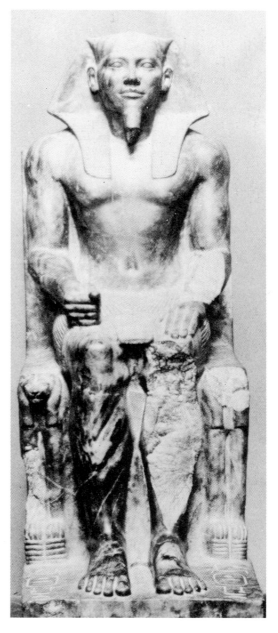

38. Khafre, from Giza. c. 2560
B.C. Diorite, 66″. Museum,
Cairo

with it for over two thousand years. The permanence of the Egyptian way and an eternal life after death were the promises of Egyptian philosophy. Built by a commanding labor force, the pyramid was, besides a colossal tomb, the pharaoh's stairway to heaven. Even the common man, if he could afford it, preferred having his tomb built of stone, with mud sufficing for his home. Life and art in Egypt revolved around a concern for the eternal. And Egyptian art primarily expresses this feeling. When we look at an Egyptian pyramid, or temple, or statue of a pharaoh we realize immediately through the massiveness, the solidity, and the static, rigid solemnity of the work how the Egyptians felt about eternity (Fig. 38).

With the Greeks it was another matter. Life was more important to them than death. And they were more than just curious about it. Their love of life and their zest for inquiry revolutionized early art.

For the first time, art gave up its role of depicting the sacred—the world of man's gods. The Greeks were after something other than the frightening solemnity of an Egyptian colossus. The Greeks discovered not so much nature—but *man*. With their naturalistic approach, their sculptural figures became humanized and the concept of "ideal beauty," as we have come to know it, came into being. They depicted man as they preferred him to be, a blend of the physical and the intellectual, not as he was (Fig. 10). Yet they were not copying nature nor were they sweetening it. The friezes of the goddesses from the temple at Olympia are far from being pretty or voluptuous, but they are naturalized and idealized. The Greek idea of perfection also included a concern for form: balance, harmony, and proportion as well as the unity and rhythm of line and shape.

This idealized naturalism, which we equate with the classical approach, has had a dominant influence on western art. Abandoned during the Middle Ages because of different life goals, it was resuscitated during the Renaissance and prevailed throughout the following centuries until recent times. In Europe there was a classical revival during the reign of Napoleon (Fig. 33), and in America during the early days of the Republic. As late as the nineteenth century, most art academies insisted upon a classical approach to drawing, painting, and sculpture.

As a result, varying degrees of stagnation took place. Instead of creating new forms for new times, most artists mimicked the past. That there were basic standards of beauty was the aesthetic code of the day. As a consequence, western man suffered from certain irrational fixations. Gothic art was considered to be barbaric; the drawings of Rembrandt, mere scrawls; Oceanic and African art, crude; Van Gogh's brush strokes, the product of a deranged mind, and Impressionism, the epitome of degeneracy.

However, constant exploration, discovery, and scholarly research finally exposed this "worm's eye" view for what it was. With the develop-

ment of the camera, as well as modern publication techniques, artists and connoisseurs were confronted with many norms for beauty. A multitude of *new* comparisons could be made. In the nineteenth century, the art of Egypt was literally dug out from under the sands of time. Trade with the Orient led to the discovery of the abstract aspects of Japanese art (Fig. 3). The explorers, Burton and Stanley, opened up Africa, and completely new sculptural motifs were revealed. In Europe itself, there was a rediscovery of the spiritual beauty inherent in the Gothic and Byzantine styles (Fig. 15)—a kind of beauty that had been present but unseen in Europe for hundreds of years. Artists began to experiment more and more with style and technique, and, finally, the old hierarchy of standards of beauty, based on the so-called classical golden age, was abandoned. From then on, beauty in art became *truly* a matter of relativity. Color could be bright or dull, space could be dimensional or flat, paint could be thick or thin, and subject matter could be treated realistically or abstractly. It was no longer a matter of right or wrong; for the artists, it became a matter of *intent* as well as degree.

Pointing out that beauty in art is relative does not mean that

39. Edward Hopper. *House by the Railroad Tracks.* 1925. Oil on Canvas, 24 × 29″. Collection, The Museum of Modern Art, New York

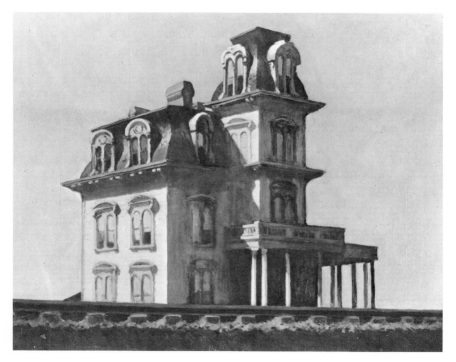

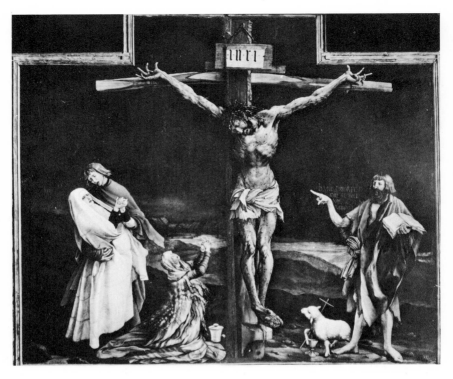

40. Matthias Grunewald. *The Crucifixion,* from the Isenheim Alter-
piece (closed). c. 1510-15. Panel, 8′ 10″ × 10′ 1″. Musée Unterlinden,
Colmar

41. Francisco Goya. *The Third of May, 1808.* 1814-15. 8′ 9″ × 13′ 4″.
The Prado, Madrid

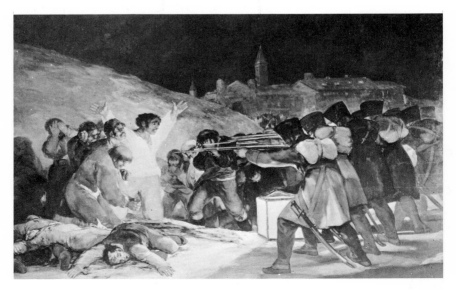

there are no standards of beauty. As soon as works of art are compared, objective standards are discovered, although the standards themselves sometimes change in time. A story by Mickey Spillane does not measure up to one by Hemingway, a musical composition by the Beatles hardly matches one by Beethoven, and similarly, in the visual arts, Norman Rockwell and Rembrandt are in quite different leagues.

That there is beauty in quality soon becomes self-evident. The style and depth of an artist's work has much to do with its greatness. The way the artist handles form and content can be aesthetically pleasing. From this point of view, beauty in art is usually broadly defined as that which is aesthetically pleasing.

Yet, even in the case of quality, it must be remembered that we are not speaking solely of intrinsic beauty. We are also dealing with subjective factors because the observer himself must have certain capabilities in order to recognize quality when he sees it. The person who likes the smiling Christ on religious calendars will not see anything of worth in a portrait of Christ by Rouault (Fig. 20). If the Fourth of July themes of Norman Rockwell make another man feel patriotic, he will hardly be moved by the regional paintings of Andrew Wyeth or Edward Hopper (Fig. 39). The sweetest or the loudest music is not always the best, but there are some people who can appreciate nothing else.

In conclusion, the more familiar one becomes with art, the more one realizes that beauty in art is relative. Universal standards of beauty are as debatable in art as they are in life. When people speak of the beautiful in art, what they are usually referring to is taste—and tastes change. Because of the times they lived in, the Victorians had little taste for such artists as Hieronymus Bosch (Fig. 24), Matthias Grünewald (Fig. 40), and Francisco Goya (Fig. 41). Because of the times we live in, the work of these painters takes on new meanings—but the quality was there from the beginning. Quality has to do with the form (the design) as well as with the depth of the statement; these are measurable as soon as comparisons are made. The power and depth of a work of art have much to do with its greatness.

CHAPTER FOUR

Art and the Idea of Progress

The idea that art should progress is one of the many clichés about art still prevalent. But this idea is troubled with ambivalence. The pattern of what we shall call the syndrome of the real, the beautiful, and progress usually goes as follows: the people who think that paintings should be photographically real and nothing but beautiful are also convinced that, as art evolved, it progressed—especially from the Renaissance on—and that this progress continued until the turn of the century—when this "crazy modern art" began. Paradoxically, it is the view of such people that art has actually become degenerate, beginning with the day abstract art came into vogue.

Obviously, this whole idea of progress in art becomes self-contradictory unless by progress one means only a specific kind of progress—progress in terms of cumulative rendering techniques, such as foreshortening, perspective, chiaroscuro, and so forth. Beyond a doubt, these innovations are often set aside by the modern artist because of a preference for others. With the invention and development of Impressionism, Expressionism, Cubism, Surrealism, and Non-Objective art, new rendering techniques have come to the fore. Perspective, chiaroscuro, and its painting counterpart, sfumato, have, by necessity, given way to techniques that we will be discussing in more detail later, such as pointillism, counterchange, collage, and frottage. Swinging away from certain technical innovations to others is not necessarily a sign of degeneracy; it may, however, be an indication of a shift in emphasis.

In cases where this syndrome has been carried to the extreme, there

can even be found among us those who have cleverly deduced that this so-called degeneration is part of a great conspiracy. These "degenerate abstractionists" are either pinkos or communists whose hearts are set on destroying our great artistic traditions (progress included). What puts the lie to such unfortunate and virtually paranoiac points of view is that so-called degenerate abstract artists are even *worse off* in Russia: There they are strictly forbidden to paint in the, to quote the Russian press, "degenerate" abstract manner.

These views are the result of misunderstanding rather than ignorance. Remember, as Americans we have inherited mainly the artistic traditions of Western Europe. By inheriting the copy-of-nature tradition and the depicting-the-beautiful tradition, people with a limited understanding of art have acquired, somewhat innocently, some wrong opinions. And, above all, the pitfall that art is a matter of progress is a natural one for Americans to fall into.

As Americans we have the tendency to measure *all* change in terms of progress. It has become our way. We have made great progress in science and technology, in education, and in human welfare. We are an optimistic people and we believe that things can be improved. But reaching for a goal, in the sense of improvement, in art is not the same as reaching for something like utopia.

Although, when we examine history, we realize that change in the human realm is not always for the better, as a people we have the inclination to disregard such facts. Similarly, although a knowledge of the history of art tells us that art is not a matter of progress (if by progress we mean improving on the past), too few people have the necessary knowledge of art to understand this. The strong inclination to see it otherwise is still there.

Today, with more facts to go by, we know that Cro-Magnon man had

42. Cave Paintings. c. 15,000-10,000 B.C. Lascaux (Dordogne), France

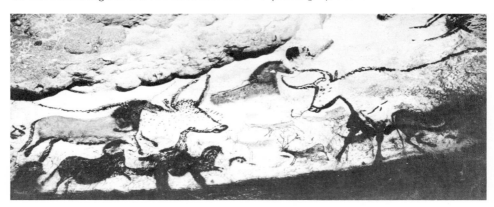

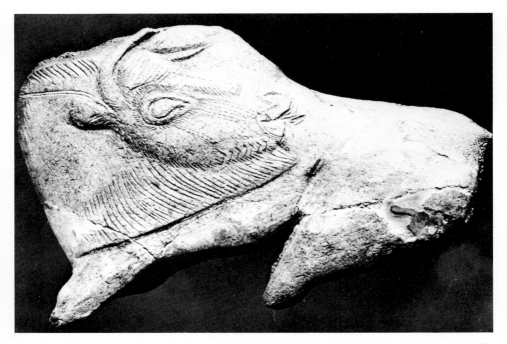

43. *Bison* from La Magdeleine near Les Eyzies (Dordogne). c. 15,000-10,000 B.C. Reindeer horn. Museum of National Antiquities, St.-Germain-en-Laye, France

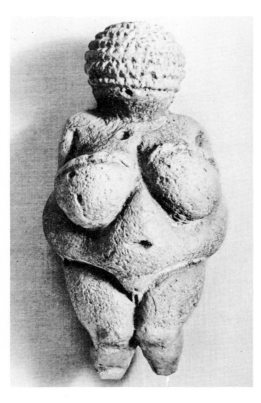

44. *Venus of Willendorf.* c. 15,000-10,000 B.C. Stone, height 4⅜". Museum of Natural History, Vienna

a brain similar to ours—no matter how much it hurts our pride to admit
it. The perceptual awareness of Cro-Magnon man was even keener. The
cave paintings of Altamira and Lascaux are ample verification of this
(Fig. 42). Few artists in the whole history of man's past have been able
to draw as well—naturalistically, that is. When these cave paintings were
first discovered, the whole art world was astounded. The walls of these
caves are covered with hundreds of animals drawn with directness and
great simplicity. These drawings were executed with such skill that, to
this day, we can feel the "presence" of these early mammals. We can feel
their movement and weight; they are alive with vitality.

Pre-historic man could carve as well as he could draw. In the famous
Reindeer horn carving that historians have named "Bison With Turned
Head," we can see that these Cro-Magnon men knew how to handle the
illusion of depth in low-relief almost as well as the artists of the Par-
thenon (Fig. 43). We also know that they were flexible in approach. They
were capable of working abstractly and symbolically as well as naturalis-
tically. Such imaginative and stylized works as the half man-like, half
animal-like "Sorcerer" and the "Venus of Willendorf" (Fig. 44) are among
the many examples of such symbolic abstractions.

Anthropologists tell us that the "Sorcerer" is obviously a drawing
symbolizing a shaman or medicine man. He is distorted in shape and
color because he has magical powers. The Venus symbolizes fertility; her
distortion is justified for religious reasons. Being capable of work-
ing in a variety of ways, these early men had no predilection for mental
strait jackets.

As we move through art history we see much change—many styles,
many ways. But these changing styles are more a matter of changing life-
views than the results of progress.

Egyptian art differed in style from Greek art just as the structures
of these two societies differed. At one time even art historians believed
that Egyptian sculptors worked in a severe, abstract style because they
were incapable of working naturalistically. Then, when some compara-
tively naturalistic sculpture, made during the reign of the Ikhnaton, was
discovered, this theory was abandoned (Fig. 45). We now know, due to
many recent discoveries, that this brief Egyptian trend toward naturalism
was a reflection of the humanistic philosophy advocated by the pharaoh
Ikhnaton. For the Egyptian of that era, there was a change in life-view.
The change in the art of the time reflected this.

Late in the nineteenth century, when the European Expressionists
became interested in African sculpture, the majority of these sculptural
pieces were considered typical of the endeavors of a primitive or backward
people. Yet we find the naturalistic refinement of the Nigerian bronzes
(Fig. 28) excavated at Ife astounding, to say the least, considering the

45. *Queen Nefertiti.* c. 1360
B.C. Limestone, height c. 20″.
State Museums, Berlin

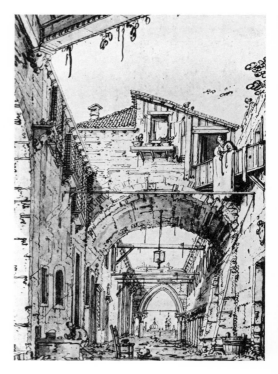

46. Canaletto. *Courtyard of a
Building in Ruins.* c. 1760.
Pen, pencil, and wash. The
Art Institute of Chicago

fact that they were made during the twelfth century—when Europe was "progressing" through the Middle Ages. In the twentieth century, our opinions about African art have been considerably revised. We now realize that there is no Negro art; there are Negro styles. As the African cultures differ in place, time, and circumstance, so does the art.

In a very recent movement called Op art, artists are experimenting with the optical effects of shape and color. This particular movement in art takes on a rather scientific appearance just as the development of perspective did in the Renaissance. But this does not mean that the painters of Op art are in any way superior to any of the great painters of the past or to any of their contemporaries working in other traditions. At one time, European artists believed that scientific perspective was a superior tool (Fig. 46). And it was, in the sense that it developed step by step from the time of Giotto to the time of Dürer. But what these European artists failed, at the time, to understand was that the artists of the Egyptian, the Byzantine, and the Asiatic civilizations would have had little use for such a tool even if it had been available to them. The artistic goals of each of these civilizations were different because their cultural goals were different.

In conclusion, we do not progress in art as we progress in science. A shift in drawing from three-dimensional perspective to multi-dimensional cubism is not a sign that the artist has become physiologically degenerate. Picasso, for instance, is highly acclaimed for his mastery of both approaches. There is development and change—but the development and change that take place are due to a constantly changing cultural and physical environment. As the earth turns, different views of life and art emerge. The way of the artist of the new day is different from the way of the artist of the old—but the quality of the work may remain the same.

CHAPTER FIVE

Art and Play

In the previous chapters what we have been stressing is the fact that, unfortunately, valid works of art are often rejected because the story element seems to be lacking, because of an indifference to form, or because the popular ideas about realism, beauty, or technical skill are not subscribed to. Related to this, but on a different plane, is the fact that some people refuse to take art seriously because they regard it as nothing more than play.

Art activity may seem to be a self-indulging and pleasurable waste of time, like play, since its products are not especially useful in the utilitarian sense. And, of course, art often stems from what may be called the play impulse. The primitive man carving on a piece of bone, the child making a chalk drawing on the sidewalk, and the artist sketching by the river bank are all enjoying themselves. What they are doing may be equated with play inasmuch as they are releasing surplus energies in a pleasurable way. Obviously, the labor of the artist differs from the labor of the farmer, the builder, and the manufacturer. But, considering the history of mankind, it is well to realize that art is more than mere play, that there are objectives to art, that art serves many practical purposes. For primitive man, art was, more or less, a form of magic; during the Early Civilizations art was mainly at the service of the Gods; in the Christian Era, it was motivated by higher religious impulses; beginning with the Renaissance, it served the Pope, the Prince, the private patron and the nation-state; and today, although we tend to regard art more as a thing in itself, this is not to say that it is purposeless, aimless, without objectives or patrons.

Those who regard art as play are usually influenced, in the moral sense, by what in America has come to be called the Puritan Ethic or the

gospel of hard work. As with most things cultural, the origin of such an attitude about art is European—in this case, the similar Protestant Ethic of the Low Countries. For example, Van Gogh's father, who was a dedicated and hard working minister, was embarrassed by the fact that his twenty-seven-year-old son wasted away his time painting instead of doing regular work. Yet, today, because of his son's work, the name Van Gogh commands the respect of the world. Obviously, the father lacked foresight. But when we realize that Vincent Van Gogh, rejected and unrecognized by his contemporaries, ended his life in total despair, it is all the more tragically ironic that his own father was so wrong.

This issue of the play factor in art can be difficult to discuss because moral beliefs are involved, and some people are sensitive to the slightest criticism in this realm. But what really makes honest discussion of the play issue difficult is the fact that some people reject art, and especially twentieth-century art, not for moral reasons alone, but because of the subjective *feelings of play* or pleasure that emanate from the work. In effect, art that looks effortless is often rejected—even if it is good. As can be seen, we are now in an even more touchy realm—that of the human psyche.

Valid works of art in our time emanate not only feelings that are akin to play and pleasure but also feelings that are akin to freedom. It is the presence of these feelings in art that is emotionally annoying to some people. When the young child is chastised for vigorously coloring the coloring-book apple beyond the printed edges and the mature artist finds himself exiled by the dictator, it is the feelings of play, pleasure, and

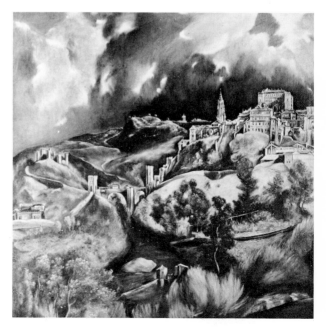

47. El Greco. *View of Toledo*. c. 1604-14. 47¾ × 42¾". The Metropolitan Museum of Art, New York (Bequest of Mrs. H. O. Havemeyer, 1929. The H. O. Havemeyer Collection)

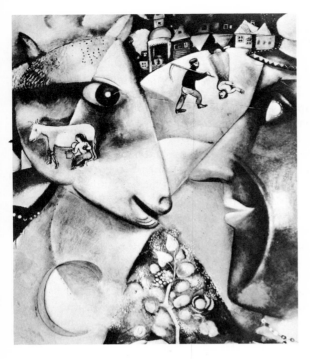

48. Marc Chagall. *I and the Village*. 1911. 75⅝". Museum of Modern Art, New York (Mrs. Simon Guggenheim Fund)

freedom in the productions of both that each of the disciplinarians is objecting to.

It is usually the case that a good painting *feels* as though the artist enjoyed making the painting, just as a musician playing in a band obviously enjoys his work. Play is not only one of the factors motivating the artist, but also one of the aspects of enjoying art. In most modern paintings and in many of the great paintings, the feeling of art as pleasure or play is definitely there. Yet, for this very reason some reject the work. The thinking goes this way: if it is work, it cannot be fun, therefore, the paintings that are the most labored over, that took the most pains, surely must be the best ones. The contrary is true, of course. The paintings that *feel* free and easy-going, that are full of life and not rigidly overworked are usually the better paintings. The cave artist, as he saw the bison (Fig. 42); El Greco, as he viewed Toledo (Fig. 47); Rembrandt, as he saw himself (Fig. 36); Rouault, as he envisioned Christ (Fig. 20); Kiyomausu, as he portrayed a woman holding a comb (Fig. 3); and Chagall, as he reminisced about his childhood (Fig. 48), all give evidence of this. The poet and critic Baudelaire expresses it this way:

> The face, the voice, the music that have true beauty belong to people too full of life to be afraid of making mistakes. When you sing it safe, play it safe, paint it safe, write it safe, you paint and write and sing the life out of it.

Apart from this aspect of Puritanism, one of the reasons why some people insist on the finished-down in art is probably a psychological one;

it can be tied to those personality traits that are affected by our social condition. Because we currently live in an age of mechanization, we tend to believe that the mechanized state of being is a natural state for man. We eat and sleep by the clock; work begins and ends when the factory whistle blows. In other words, we tend to live compulsively. It becomes easy for us to believe in the stereotyped concept of work: all work requires effort of a painstaking sort. But does it? A good swimmer enjoys the water, a good ballplayer likes the game, a good writer wants to write, and a good musician enjoys playing just as a good artist enjoys painting or sculpting.

As many post-Freudian psychoanalysts such as Wilhelm Reich and Erich Fromm have pointed out, because most people find their own work to be drudgery they sometimes sub-consciously hate to see others enjoying themselves at their work. For example, the typical night club manager hates to have to pay his musicians for their practice time, especially when they have so much fun practicing. And so it goes that if a work of art sings with the pleasure of its creation, it will be, by its very nature, rejected by some.

There are other reasons, of course, for some people insisting on "finish" in art (such as some of the nineteenth-century attitudes about art discussed earlier), but one more important conditioning factor may be attributed to our new age of machine technology. We are so entranced by machine processing that we tend to regard the handmade as inferior and second-rate. The beauty in the variability of each handprinted wood-cut is something that has to be explained today, not to mention smudges on charcoal drawings, brush marks on oil paintings, and chisel marks on stone sculpture. For some, seeing the handpainted original in the museum after first seeing it reproduced in full color on slick paper in a magazine can be a disappointing affair. The cartoon of the little girl standing by the edge of the Grand Canyon, telling her father that the colorslides were even nicer, is, thus symptomatically revealing.

When a painter paints and a sculptor carves, they are functioning as living, breathing human beings. The give of the canvas to the brush and the resistance of the stone to the chisel are part of the joy of the act. This interaction of the man with the materials is again one of pleasure— pleasure in the doing, pleasure in the work. These pleasurable feelings of interaction, in this sense, are organically felt by us as we contemplate the art object: empathy, or a feeling into the situation, is at work. It is highly improbable that the artist, who has good feeling for his materials, would wish to disguise their characteristics. Thus the admirer of Rembrandt is fully aware of how he manipulated the needle in his etchings as well as the brush in his oils. Nor is the sculptor Henry Moore annoyed by the grain of the wood or the stone as he carves—he works with it (Fig. 19). In contemporary painting this interaction of the artist with his materials is especially apparent in the movement called Abstract Expressionism.

Such painting is appropriately called action painting. Not only do we sense vividly how the materials are being used but also the physical action of the artist as he uses them: how he wields the brush, or in the case of Jackson Pollock, how he drips the paint and how he moves about (Fig. 4).

All of this is foreign to machine production. And the contemporary artist is concerned about the hypnotic effect machine finishing has had on our tastes to the extent that his work virtually cries out: "As artists, we are men; we are human; see what we can do—directly—by ourselves, with only simple tools in our hands!"

In returning to our discussion of art as play, it is necessary to point out that art is not limited to play. Rembrandt was not playing when he painted his portraits. Nor was Michelangelo playing when he spent four years on his back (with plaster dripping into his eyes) painting the Sistine Ceiling. Michelangelo spoke of himself as a physically broken man afterwards. He loved his work and he enjoyed it, but it went beyond pure play, to say the least. The essential point is that artists do not approach their work compulsively. A good artist approaches his work in a natural, functional way. An artist paints because he *wants* to paint, not because he forces himself to.

We have now considered the following ideas: Some people reject art simply because it looks like play and, to such people, anything that has to do with play cannot be meaningful work. In this connection the majority of people still approach their work compulsively. Artists cannot afford to function in this way because the feeling of art as pleasure or play is a part of the appeal of the art object. In addition, because of the conditioning of machine technology, we tend to reject art that gives evidence of a healthy interaction between the artist and his materials. And, finally, art goes beyond play. At this point the following question still needs to be pursued. Why are the feelings of play, pleasure, and freedom factors in the appreciation of art?

The proper understanding of what constitutes freedom in art requires an understanding of the anabolic or life-affirmative character structure of man. Not only are there symbiotic relationships between life, freedom, and art but there are similar relationships between these and the painting process. These things are inseparable when it comes to art. And, by necessity, we shall speak of them in the symbiotic sense.

THE LIFE-ENHANCING ASPECTS OF ART

A true work of art is uplifting or inspiring; it makes us feel not only glad to be alive but proud to be human. In this sense, a work of art is life-enhancing. And, as Bernard Berenson has pointed out, in order for a work of art to be life-enhancing, we must be able not only to

identify ourselves with it, but also to do so in an easy-going way.[1] In a sense, we are charmed by it. On the other hand, if a work of art makes us feel despondent or tired of life (life-negation) we would not treasure it or preserve it. Because of its life-negative qualities it would soon be rejected as art; it would not be passed on, and would not survive the test of time. This is not to say that all artistic comments must be of a positive nature. Picasso, in his *Guernica* mural (Fig. 7), depicts the brutality of war; Rembrandt, in his *Self-Portrait* (Fig. 36), speaks of the tragic; but both paintings remind us of the possibilities of human dignity. If the deadness or negativeness is in the handling of form that is another matter. Now, in essence, play or pleasure has to do with a love of life, in much the same sense as a young child approaches life openly and unafraid. Like the child, the artist must express himself as a fully-living human being. In order to produce work that is significant he must be mobile, free, and full of expression. He must be energetic, creative, and courageous. Like the child, he must make the best use of his sensory equipment, perceiving critically and seriously. He must be direct, truthful, and sincere. He must look for the essence of things and he must be capable of expressing himself energetically and spontaneously. If he is capable of functioning in this way, the spectator will be able to identify with the life-affirmative feelings that are present in his work.

Yet, because of personality factors there are people who will shy away from art that radiates the feelings just described. We must remember that even the ease, freedom, and spontaneity of a child are frightening to the puritanical, conservative, or strait-laced. So, when such people encounter similar feelings of play or pleasure in a work of art, they become afraid and subconsciously reject the work.

By way of a contrasting illustration, let us consider the kind of painting that the strait-laced personality might attempt. What kind of a painting would it be? Would it be on a small canvas? Would it be painted with a tiny brush and with the minimum amount of paint? Would it be carefully painted in from the top down or the bottom up? Would we be able to discover, carefully painted, every brick in the house, every leaf on the tree, and every blade of grass? Would the brush strokes be smoothed down in the sky and would the sky be blue and the grass green? It would—and such a painting would never amount to anything as art. To interject a thought, what about Grandma Moses?

In the case of Grandma Moses it is well to remember that although she lived to be an old lady, she was not strait-laced. She loved life, and her paintings, in spite of her tiny brush, expressed this love of life. For her, the sun shone, the clouds rolled, the wind blew, the snow fell, and children ran and played with abandon. It is because these feelings are

[1] Bernard Berenson, *Aesthetics and History* (New York: Doubleday & Company, Inc., 1953), p. 67.

expressed in her work so well that we admire her as a *primitive* or *folk artist*. Furthermore, she painted because she enjoyed painting. If you look seriously at her work, you will find this to be true. And it is true primarily because of the strong feelings of *life-affirmation* that reside in her work.

To understand adequately the life-affirmative or the life-enhancing aspects of art it is necessary again to differentiate between form and content. For example, a painting may be life-enhancing because of the creative treatment of the *form* and yet deal with the theme of life-negation as far as *content* is concerned.

Picasso's famous mural *Guernica* (Fig. 7) is a painting of this sort. The *content* has to do with the life-negative aspects of war: in this case, the bombing of civilians in the town of Guernica during the Spanish Civil war. But even in this matter of content, is not Picasso speaking out in the life-affirmative sense when he pulls no punches in denouncing war and depicts its horrors with such acidity? The theme is of a negative nature but the truthfulness with which it is handled is what is to be admired. Most admirable of all, however, is his treatment of the *form*. The lines and shapes are exciting and new; Picasso is as creative and inventive as always. Through exaggeration and distortion in the handling of form, Picasso conveys the *feeling* of the horror of warfare. Jagged shapes, spiral lines, and diagonal movement convey the feeling of bombs blasting. Black, white, and grey colors convey the feeling of death. Because of the style, gaping mouths and twisted hands and joints convey an empathetic message that leaves no one in doubt. At the same time, Picasso builds a visual structure that can be aesthetically pleasurable to view. The lines and shapes are dynamic, the positive and negative spaces are in harmony, the dark and light pattern is balanced. The form of the painting is a thing to admire.

Because of the form, the things that we recognize—a bull, a horse, a child, hands, faces, a light-bulb, a sword—are presented in a frightening way. But, in terms of identification alone, they act as *symbols* and are part of the *content* of the painting rather than of the *form*. Again, *form* and *content* are best understood together in a work of art: they are not really separable. If, in order to clarify a point, we separate the inseparable with words, it is well to keep in mind that the words describing the art object are not the art object itself. A work of art is all-of-one-piece. Nevertheless, in the case of the *Guernica* mural it may be said that the content has to do with life-negation, but the form is, beyond a doubt, life-affirmative.

At first glance, Rembrandt may appear to be another artist whose work is tragic in content. But it is not, really. In spite of the fact that we often see bedraggled or crippled people, or tired old people with sad expressions, because, through their faces, Rembrandt speaks of human

dignity in the face of the tragic, his statements are uplifting and life-affirmative. His is heroic tragedy. And by no means is Rembrandt negativistic when it comes to his treatment of the form. Here he does not borrow or copy from his contemporaries, or reanimate old techniques. His handling of light is unique; his brush, as it works and reworks the paint on the canvas, has no duplicate. And in this special sense it is his use of the brush, painting as a man "drunk with paint," that puts Rembrandt under the banner of life-affirmation. Rembrandt's greatest paintings are those which are the most painterly. It was in his late years that he became most alive as a painter. He was always a good technician but some of his earlier paintings, rendered with exacting detail, suffer from the fact. Quite often people are fooled by such things.

This matter of continuous growth and development is another identifying mark of the life-affirmative artist: not to rely on formula, not to be afraid, to go into the new and the unexplored, to be aware, and to probe deep. And probing deep does not mean complicating things. Again the life-affirmative artist seeks the essence of things rather than their complexity. In ignorance, the man in the street often equates the direct simplicity and freedom that can be found in the late work of Rembrandt,

49. Henri Matisse. *The Joy of Life.* 1905-06. 68½ × 93¾". Copyright 1966 by The Barnes Foundation, Merion, Pennsylvania.

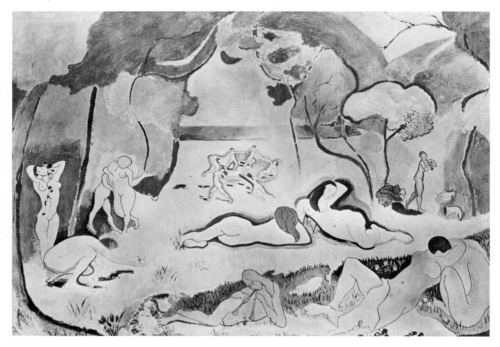

El Greco (Fig. 47), and Michelangelo (Fig. 35) with a loss of energy—
something that goes with old age. On the contrary, it was the desire of
these artists in their late years to express themselves as directly and freely
as possible that made them work that way. In a sense, they were more
alive than ever before. The fear of being expressively alive is something
that is foreign to the life-affirmative artist. But to paint as though full of
energy, to be free and easy-going as an artist is no easy task.

Another artist who constantly strove for easy-going simplicity was
Henri Matisse (Fig. 49). He wanted his paintings to appear as though he
painted them as he sat relaxing in his armchair. When we look at his
work we do not realize the amount of time and effort that went into its
production, nor did Matisse intend us to. He did not want his art to
have a "tired-out" look. He wanted all of his paintings to look as though
they were freshly painted—dashed off in a matter of a half-hour or so.
This is what he felt art should look like and *feel* like.

To sum up: The "look" of the pure pleasure of doing is a part
of the aesthetic appeal of the art object. Also: The importance of art as
play and the life-enhancing aspects of art are interrelated.

As a tool for evaluating a work of art, what follows is a chart com-
paring the life-affirmative aspects of art with the life negative. Of course,
in any work of art, the difference between the life-negative and the life-
affirmative is not a matter of either-or, but of degree. The categories in the
chart are applicable to the artist's handling of content as well as form.

The value of this chart lies in the fact that it may be used by any-
one, regardless of his knowledge of the elements and principles of design
or composition. For the person who is interested in learning more about
composition, there are numerous well-written and scholarly books on the
subject.

The limitation of this chart lies in its uniqueness. It is psychological
rather than analytical; it is perceptual rather than conceptual. Therefore,
it can serve as a tool for evaluating a work of art provided the spectator
is *capable* of "sensing" the difference between life-affirmation and life-
negation. The following chapter will be helpful in this regard.

Further, we should like to point out that this chart is related to the
findings of Wilhelm Reich and other psychoanalysts such as Erich Fromm
and Karen Horney—especially in regard to the psychodynamics of
life-affirmation.

A Comparison of the Life-Negative and Life-Affirmative Aspects of Art

The more life-affirmative the work, the greater the quality.

Life-Negative	*Life-Affirmative*
Rigid—limited expression	Free—full expression
Fearful	Unafraid
Immobile	Mobile
Shallow in feeling	Deep in feeling
Lacking energy	Full of energy
Lacking contact or use of substitute contact	Full of contact with materials and life
Dead in sensory equipment and approach	Alive in sensory equipment and approach
Unaware of materials and world	Aware of materials and world
Lacking development in work	Showing development in work
Borrowed or stolen	Created
Static: lack of pulsation	Kinetic: in idea and treatment
Imitative	Original
Irrational and intolerant	Rational and tolerant
Seeking absolute rigid formula	Aware of the changing fuctions
Frivolous	Serious
Cowardly	Courageous
Lifeless	Spontaneous
Limited in perception	Unlimited in perception
Flippant	Sincere
Devious	Direct
Overworked	Looking for the essence of things
Experiencing indirectly	Experiencing directly

CHAPTER SIX

How to Evaluate
a Work of Art

In the previous chapters, as we have considered the problems of looking at art from various standpoints, we have, of course, made frequent reference to the matter of quality. But, except for the preceding section on the life-enhancing aspects of art, we have not dealt extensively with the problem of evaluating the art object from the standpoint of design: the matter of arranging, organizing, and coordinating the plastic factors. Because of a neglected education in design, most people have no way of determining whether a work of art is good or not. If it is famous, of course, they are willing to admit that there must be something to it, but if it is a contemporary piece by a local artist, who may or may not be good, they are at a loss as to how to evaluate it.

Before proceeding directly with an exposition of the factors of design, let us pose some questions: Since currently there is such a separation between the artist and the layman, is it not best to leave all decisions about the value or quality of a particular work of art to the experts? Since the training of the artist is so specialized, isn't it true that even the person with a learned background in the history and literature of art has difficulty making quality judgments? Since matters of taste are so variable, so complex, so personal, since they often involve such controversial matters as home, Mother, God, and country, isn't it best to leave each to his own when it comes to picking and choosing pictures?

A healthy answer to any of the above questions is: NO! Nevertheless, a good many people have convinced themselves that the task of judging the validity of a particular work of art is just too great. It is a

challenging task, but only in the sense that art is something that should be taken seriously. Moreover, art is one of the great media of human communication; it is important to human living and should be understood *functionally*. For an educated citizenry not to be able to cleave it is most unfortunate. Actually, any mentally healthy person who is not afraid to put his full sensory equipment into play can be equal to the task.

As a matter of fact, the language of art is one of the easiest languages to learn once one knows where and how to start. The place to start is not with a book on art criticism, not by calling upon the museum critic —the place to start is with one's self.

Each man carries within himself all of the perceptual tools that are required in order to understand art competently. We have touched upon the importance of full sensory aliveness in early chapters. We discussed such topics as the art spectator's qualifications, art and the play impulse, and the life-enhancing aspects of art. Next, we shall consider the relationship between the sensory aliveness of the individual and the compositional devices used by the artist. It is only by putting our full sensory powers to work that we communicate with the artist as he composes with line, shape, color, and texture. How are feelings conveyed by the various compositional devices of the artist?

MAN'S EMPATHIC REACTIONS TO SHAPE, FORM, AND COLOR

To all human beings, whatever their race or locale, a vertical line in a painting denotes strength or stability; a horizontal one, peace and repose; a diagonal one, unrest and movement. In nature, the tree that grows straight is the strong one. In art, the emphasis on verticality in the columns of the Parthenon (Fig. 2), in the elongated figures from the Cathedral at Chartres (Fig. 16), and in Michelangelo's figure of David (Fig. 1) helps convey this feeling of strength and stability. In nature, the distant horizon is level and peaceful. In art, the horizontal is stressed for this very reason in such familiar paintings as Bingham's *Fur Traders Descending the Missouri* and Rousseau's *The Sleeping Gypsy*. On the other hand, by emphasizing the diagonal, a feeling of unrest and instability is conveyed in De Chirico's *The Evil Genius of a King* (Fig. 37), just as movement is conveyed in Duchamp's *Nude Descending a Staircase* (Fig. 50), and Myron's *Discobolus* (Fig. 10). Our emphatic reactions to linear factors of one sort or another grow out of our orientations to nature.

Everyone knows that a jagged, angular shape conveys one kind of a feeling, a soft, organic shape another. In nature, a soft, fluffy cloud feels different than a hard, jagged iceberg. Rounded, organic shapes are appropriately stressed in Matisse's *The Joy of Life* (Fig. 49) as, just appropriately, are angular ones in Picasso's *Guernica* (Fig. 7).

In nature, we feel the warmth of the sun on a summer day, while at

50. Marcel Duchamp. *Nude Descending a Staircase, No. 2.* 1912. Philadelphia Museum of Art (Louise and Walter Arensberg Collection)

51. Alberto Giacometti. *City Square.* 1948. Bronze. Museum of Modern Art, New York (Purchase)

52. Donatello. *Mary Magda-len* (portion). c. 1454-55. Wood, height 6' 2". Baptistery, Florence.

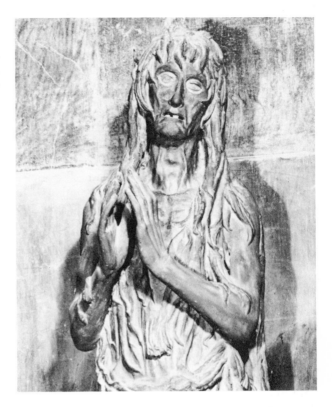

53. Meret Oppenheim. *Object.* 1936. Fur-covered cup, 4⅜" diameter, saucer, 9⅜" diameter, and spoon, 8" long. Collection, The Museum of Modern Art, New York (Purchase)

the same time the sparkling, blue waters of a mountain lake feel cool. Similarly, in art, brilliant red-oranges are always warm or hot compared to blue-greens, which are cool.

It should be pointed out, however, that although we respond in the universal sense to the warmness or coolness of a color and its gayness or somberness, other responses to color often depend upon the manner in which the color is being used or what a particular color may symbolize in a given culture. For example depending upon the situation, the color red may be associated with *any* of the following: love, passion, sin, bravery, violence, war, blood, fire, and communism.

In nature, the texture of silk feels soft, that of sand, coarse. In most works of art, tactile factors are also present. We respond as much to the texture of the painted surface in the works of such artists as Rembrandt, Van Gogh, and Rouault as we do to the sculptural in wood, stone, or metal by such artists as Rodin, Moore, or Giacometti (Fig. 51). In some works, tactile sensations are of major importance, such as in Donatello's *Mary Magdalen* (Fig. 52) and Grünewald's *Crucifixion* (Fig. 40), not to mention Oppenheim's bizarre, surrealistic *Fur-Lined Teacup and Spoon* (Fig. 53). Again we react *empathically* to all lines, shapes, forms, colors, and textures.

By definition, *empathy* is a feeling into an object or a situation. It has to do with knowledge gained through past experience and through intuition. In the machine age, we could say that it is the hidden language, inasmuch as we tend to hide ourselves from its possibilities. Today, we tend to deny ourselves the natural pleasure of reacting empathically and understanding perceptually. We tend to rely on conceptual knowledge entirely and this interferes with our understanding of art. By revitalizing ourselves in the realm of perceptual functioning, the language of art can be understood. And this is something that we can well afford to do. The poet Wordsworth put it this way:

> The world is too much with us; late and soon,
> Getting and spending, we lay waste our powers:
> Little we see in Nature that is ours;
> We have given our hearts away, a sordid boon!
> The Sea that bares her bosom to the moon;
> The winds that will be howling at all hours,
> And are up-gathered now like sleeping flowers;
> For this, for everything, we are out of tune;
> It moves us not.—Great God! I'd rather be
> A Pagan, suckled in a creed outworn,
> So might I, standing on this pleasant lea,
> Have glimpses that would make me less forlorn;
> Have sight of Proteus rising from the sea;
> Or hear old Triton blow his wreathèd horn.

Prehistoric man was more aware perceptually. Before the written word, what we call conceptual thinking was less important. The cave man knew how to draw the bison because through "perceiving" he knew what the bison was like (Fig. 42). Artists, of course, rely on this perceptual sort of functioning as much today as always. The American Poet Walt Whitman spoke of this matter of natural perception versus unnatural conception in terms that we can all understand:

> When I heard the learn'd astronomer,
> When the proofs, the figures, were ranged in columns
> before me,
> When I was shown the charts and diagrams, to add,
> divide, and measure them,
> When I sitting heard the astonomer where he lectured
> with much applause in the lecture-room,
> How soon unaccountable I became tired and sick,
> Till rising and gliding out I wander'd off by myself,
> In the mystical moist night-air, and from time to time,
> Look'd up in perfect silence at the stars.

It is no accident that the pyramids, which symbolized a stable Egyptian society, had a solid, broad base; nor was it accidental that most Christian paintings of the early Renaissance, having Christ at the center, were triangular compositions: Christ was the stabilizing force. When El Greco painted his ascension panels he made use of the S curve, just as did Van Gogh with his *Cypress Trees* (Fig. 11) and Munch with his *Scream* (Fig. 31): the curve "carries" the eye along. Picasso chose gray for his mural on modern warfare *Guernica* (Fig. 7): gray sets the mood of death and destruction. Mondrian used squares of bright yellow and red for his *Broadway Boogie Woogie* (Fig. 5): the bright colors and square shapes go with the music of the big city. In every case, the selections made, of a particular kind of shape or color, were appropriate, even though the selections may have been made intuitively.

The non-artist may claim to know nothing about these matters, but do not be naive. Empathic factors are constant and universal. Let us assume that you have been invited to see a recent painting of a famous battle scene made by a local artist. Let us further assume that it is painted in colors of baby blues and pinks, that it contains only soft flowing lines, no dark and light contrast and no paint texture. Now, in spite of the title of the painting and its narrative qualities, do you suppose you will still be unable to evaluate it as a battle scene? The American philosopher John Dewey, in his book *Art as Experience,* had this to say about works of art that fail to function well empathically: "If one examines into the reason why certain works of art offend us, one is likely to find that the

cause is that there is no personally felt emotion guiding the selecting and assembling of the materials presented."[1]

EMPATHY AND THE BASIC PRINCIPLES OF DESIGN

The following have long been considered to be the basic principles of design: balance, rhythm, harmony, contrast, proportion, progression, repetition, variation, and unity.

All of these principles can be found, in one form or another, in nature. For example, night is in contrast to day, there is rhythm in the swirl of a shell, there is variation and progression in the ripples and waves on the water. Everyone who is sensitive to nature is aware of these principles, for they can be felt intuitively and empathically.

Take just one example from our list—balance. Balance is demanded in man by nature and man responds to its presence or absence in art. Why? Because the physical world we inhabit has mass and weight, and the force of gravitation acts upon us constantly. By necessity, we balance ourselves as we walk and move about from childhood on. As man evolved, he inherited from nature a body equipped for balance. When our sense of balance is disturbed we become frightened and nauseated. For just such *organic* reasons, we also demand balance in a painting. On the other hand, a painting that is out of balance is disturbing.

Some artists handle balance well in their paintings; others do not. However, to the degree to which you, as a spectator of art, are sensitive to balance, you should be capable of determining whether the artist handled it well or not. To do this, the capacity to feel *into* the situation is *all* that is required.

All of the basic principles of design are related in a similar way. And for similar reasons we respond empathically to all lines, all shapes, and all colors. The way such ingredients are combined and arranged by the artist and the way in which they fit the purpose or intention of the work of art determines the success of the statement.

Again, when it come to evaluating a work of art, if you are fully alive and have a healthy sensory contact with nature, *let your feelings be your guide!* And remember, any self-crippling of sensory contact acts as a barrier to the perceptual understanding of art just as mental laziness interferes with intellectual understanding. However, unlike the intellectual aspects of art, the perceptual requires no formal educational background.

[1] John Dewey, *Art as Experience* (New York: Minton, Balch and Co., 1934), p. 68.

CHAPTER SEVEN

The Personality
of the Artist

THE STEREOTYPE VIEW OF THE ARTIST

The artist, as he is visualized by too many people, is some sort of an odd-ball or beatnik: a bohemian with long hair and shabby clothes who lives in a garret and refuses to work for a living. This is a stereotype view, of course, and it would be an easy matter to dismiss it by simply pointing it out as such. But this solves nothing. The man in the street is going to be just as convinced as he ever was that the artist is odd—that he *is* different. And, actually, he's right, but by way of an upside-down, "Alice in Wonderland" kind of reasoning.

HOW CLICHÉS WORK

To appreciate how this reasoning works we need to consider how clichés work in general. Clichés about types of people usually have some basis in fact but they primarily debunk or discredit. For example, we have all heard of the absent-minded professor. There is a reason for calling the typical scholarly person absent-minded. But such a person is not absent-minded because he is stupid (as the cliché implies), he is simply preoccupied with matters other than the commonplace. To take another example, there is the neurotic psychiatrist. Comedians and cartoonists

have a great time with him, but they are able to single out his personal behavior in particular simply because, in their ignorance, they fail to realize that *everyone* is neurotic to a degree—psychiatrists included. Similarly, for each cliché about the artist there is a kernel of truth—but the truth becomes hidden in the cliché. Surprisingly then, by examining the clichés about the artist we can come to understand him better because, although we will find him to be different, we will find a *rational* basis for such differences.

THE CREATIVE PERSONALITY

Some of the clichés about the artist apply to creative people in general. In recent years, a great deal of research has been conducted in an attempt to discover the true nature of the creative personality—from the six-year study made by the University of California's Institute of Personality Assessment and Research to the Pennsylvania State University studies of Dr. Lowenfeld. The findings indicate that creative people cannot be easily pigeonholed: they are individuals like anyone else. However, because their goals are different, they often appear to behave differently. But, as with the cliché, the "kernel of truth" that is the basis for the difference is the clue to better understanding.

To begin with, it is quite possible for the creative person to forget about having his hair cut, his suit pressed, and his shoes shined. To be smartly dressed is sometimes of little importance to creative people. Albert Einstein is a good example. Although he was not an artist, he was a creative personality. As long as the world remembers him, as a person, he will be visualized as a simple, friendly man with long hair and a sweatshirt—and that is all.

The creative person's everyday behavior is also suspect. People who work creatively do not approach their work compulsively. Since most people do, this in itself breeds resentment. However, in order to create, one must be capable of creative functioning. Creativity is, for the most part, an intuitive process: it cannot be forced, it cannot be relegated to the production line or regulated by the time clock. Therefore, by the very nature of his specialty, the creative person, as a worker, is different and he stands in opposition to an attitude about work that has become commonplace. Furthermore, the creative person seldom works in a group. Because of the nature of his work he most often works alone. Nor is he especially interested in practical problems. Everyday details hold no fascination for him. He is concerned with the more abstract meanings and implications of things and ideas. Nature, beauty, truth, and the meaning of life are among the things he is concerned with.

In day-to-day living, because creativity simply cannot be regulated, the creative person is forced to ignore the daily routine. The creative per-

son cannot be like the widow of whom Mark Twain's Huck Finn said: "the Widder eats by a bell; she goes to bed by a bell; she gits up by a bell—everything's so awful reg'lar a body can't stand it." The time-clock living that most of us accept without question comes in conflict with the creative process. Creative people must be self-regulated.

When we stop to consider how far we have come along the time-clock road since the days of Huckleberry Finn, it becomes apparent that to function in a self-regulated way is to function in a more naturally human way. In this regard, it is not the creative person who is out of step. It could well be that the creative personality is the more normal personality, in effect, an individual in an industrialized, mechanized, automated mass society. It could be that instead of looking upon such people askance, we would benefit more as a society by seriously considering their different set of values.

THE ARTIST MUST STEP OUT OF THE MAINSTREAM

According to the studies that have been made of the creative personality, the artist has a tendency to be introverted and socially retiring. He cannot afford to become too active in the social sense. The expression "gone Hollywood" refers to the artist who has become a social success at the expense of his genius. Because he must step out of the main-stream of things, he is often unfairly accused of being self-centered and of having narrow interests—even though his work may be a manifestation of broad interests. The truth is that, in order to remain creative, the artist needs freedom to select his own goals.

PLAYING THE ROLE OF THE ARTIST

Unfortunately some psychically insecure individuals find satisfaction in "playing" the stereotype role of the artist. Such people usually play the part right up to the hilt: beard, beret, garret, and all. Such obviously false behavior is embarrassing to everyone, the genuine artist and public alike. It is well to remember that this kind of stereotype character can be found in every profession, however, from the cop on the beat to the minister in the pulpit. The important thing to remember is that an artist is not to be measured by his appearance.

AN ARTIST IS MEASURED BY HIS WORK

As we have said, the measure of an artist is his work, and his work alone. The work must speak for itself. To appreciate Michelangelo, Rembrandt, Picasso, or any artist, it is not necessary to know about that artist as a person. Everything that is to be said must reside in the work. And

again, even the title of the work is of no consequence. The title is simply a cataloging device for a work of art. If you have to read the title to understand the painting, something is wrong with you or the painting. You may not be capable of understanding it, or it may not be an understandable statement.

THE DIVIDED SELF OF THE ARTIST

The work of an artist is not necessarily an expression of his everyday personality. Rather, the work is a manifestation of the artist only in the ideal sense. It is, in Bernard Berenson's phrase, the Ideated-Self.[1] In this sense, whereas the artist as a person is a complex being with all the human shortcomings who, like all human beings, may armor himself as a means of self-protection, he does not have to carry this armoring over into his work. Thus, we can view the artist as a divided self: As a man he is ordinary—his special talent is limited to his work. Since in his personal life the artist is as capable of failure as any man (it is in the special realm of art that he is most successful), it is the short-sighted person who is disappointed when he discovers that the artist has limitations in the human realm.

THE BARRIER OF SPECIAL TALENT

In regard to his work, the artist is also seen as an outsider—a man apart. He is held in awe but also regarded with suspicion. To the layman, the ability to draw is an almost magical feat. The artist is like the magician or witch doctor; he conjures up something out of nothing. Because of their magical nature, such abilities leave the average person spellbound and suspicious as well. The artist is admired and mistrusted at the same time.

THE NATURE OF THE CREATIVE PROCESS

Being creative and constantly searching, the true artist *cannot* be conventional in his work. By being merely "conventional" he would not be accomplishing anything as an artist. In order to create he must venture into the unknown. This is often cause for additional misunderstanding and mistrust. Out of necessity, by going his own way, by not conforming in his work, he often becomes the target of witch hunters.

Moralists, Puritan reformers, book-burners, and totalitarian personalities in general hound the artist out of hate. True, he is often their enemy. Artists have stood in opposition to totalitarianism from time immemorial. But most pertinently, it is important to point out again that

[1] Berenson, *Aesthetics and History.*

the *feelings* of freedom that permeate modern art are especially annoying to the more rigid character types. For instance, in Jackson Pollock's *Number 32* (Fig. 4), the artist is as free with paint as a six-year-old. (Of course, in his case there is control whereas in the case of the child there is usually lack of control.) It is the free and easy-going spontaneity of childhood felt in the works of Pollock, Chagall (Fig. 48), Klee (Fig. 54), and others that the strait-laced personality objects to. Thus, earlier in the twentieth century, modern artists were invited by Lenin to Russia to enhance the brave new world of Communism. After two years, their works were banned and they were forced to go elsewhere. Shortly thereafter, Hitler and his storm troopers chased some of Germany's most renowned artists out of their homeland. And, significantly, in the majority of these cases there was no political content in the works of the artists involved. What was involved was their creativeness.

In conclusion, to a degree the artist is an outsider. Sometimes he has no other choice. He must step out of the mainstream and view life as a man apart. But above all, he is an individual like anyone else and not a stereotype. True, you may sometimes find him in a beard or a beret but you may also find him looking and acting quite ordinary. If, on occasion, he seems to go a different way, try to understand why.

THE DEVELOPMENT OF THE ARTIST

Along with the clichés about the artist as a bohemian, there are clichés about the development and growth of the artist. Again, it is in

54. Paul Klee. *Old Man Figuring*. 1929. Etching. The Museum of Modern Art, New York (Purchase)

the examination of the kernel of truth in the clichés that the real truth is revealed. What are the clichés in this case?

There is the mystical or metaphysical cliché: the artist's talent is something that comes out of the blue, it is something that he is born with or mystically acquires. In this sense, his talent is sometimes referred to as "God-given." In Hans Christian Anderson's fairy tale, *The Red Shoes,* the child sees the red shoes, puts them on, and is forevermore compelled to dance. By analogy, one of the implications in the mystical cliché is that the artist is born with such a pair of red shoes and is, therefore, compelled to paint. The cliché has its kernel of truth: artistic performance does stem from an urge or an *impulse.* But the impulse is nothing mystical. It is not the ordinary impulse most children have to just draw and paint, but an impulse to draw and paint like *someone else.* The artistic urge of the young artist stems from a serious, conscious interest in the drawing and painting *styles* of his companions, his peers, or his predecessors in art.

Imagine, in prehistoric times, at Altamira or Lascaux, the young, uninitiated artist being taken for the first time into the bowels of the earth to see the wonderful animals painted on the walls of the cave. The Stone-Age child had seen the same animals often in everyday life, in nature, but he had never seen animals such as these—animals drawn by the hand of man. It is the Art of Mankind that quickens the artist. And it is precisely at this stage that the artist begins to wear the red shoes. The young Michelangelo was inspired by the artistic statements of Giotto, Masaccio, Botticelli, Donatello and della Quercia; Van Gogh's first serious attempts at drawing were done in the manner of Millet; and Picasso, "the constant innovator," has never let up in his exploration, examination, and resuscitation of virtually every major artistic tradition known.

Another cliché, bordering on the mystical, is the "special-seeing" cliché: the other special gift of the young artist is that of seeing nature somehow differently. Out of his different reaction to and interaction with nature, intense feelings build up, or well up, in him and he virtually bursts forth with "beautiful paintings." Contrary to the cliché, the original stimulus for the young artist is *not* nature (which, however, becomes an important factor at a later stage). In this regard, the parents and teachers who hope to quicken artistic talent by taking children on frequent excursions in the gardens of the world are not likely to discover such talent any more than those who foist coloring books on the child. The potential artist's emotions are stimulated by contact with the work of an accomplished artist.

Any sincere artist knows that in order to develop he must find himself through his work. From the beginning, the ability to draw and paint is not something that comes naturally. The artist has to

develop a style, and this personal style will stem from or develop out of the stylizations of his time. In the early stages of his development, as we have mentioned, the artist is conditioned by contact with the work of another artist. He wants to paint as "that man" paints; he is moved by the visual experiences of the work rather than by what the work represents. This is the basis not only of stimulation, but also for a personal conflict that must be resolved if the artist is to grow: he must emancipate himself from the *power* of his teacher or predecessor if he is to become a true artist.

Another important aspect of the artist's maturation and growth is the need to rid himself of the surface mannerisms of his time. For example, early in his career as a painter Van Gogh was stimulated by the style of Millet. Still searching, he next went to Paris, where he was introduced to the works of the Impressionists. By that time Impressionism was taking on the features of a movement or a school, and, in the process of becoming formalized, the style was losing its freshness, originality, and vitality. As an ordinary artist, Van Gogh could have simply followed in the footsteps of the first Impressionists. He experimented with the broken-brush stroke technique as well as the color palette of the Impressionists but was still not satisfied. He left Paris and went to Arles in the South of France, where, at this stage in his development, his contact with nature took on new meaning. Intuitively he put the brightly-colored palette of Impressionism to the service of the hot sun of Arles. A new style emerged, the style of Van Gogh. He had emancipated himself from the style of his time. He had found his own individuality. He had found himself as an artist. Thus it was not originally, but ultimately—out of many years of struggle with the problems of art as well as out of a genuine contact with nature—that Van Gogh found his personal voice as a painter.

The careers of other important artists give evidence of a similar process of development. Rembrandt started out as a typical Dutch Realist but he was eventually to concern himself with statements about mankind that went beyond mere realism. The young El Greco was a product of the Venetian school who only gradually abandoned the mannerisms of the Venetians. Mondrian began as a Post-Impressionist only to paint, for a while, expressionistically, and then more and more abstractly until, eventually, be became one of the originators of Non-Objective Art.

The study of creative functioning and creative genius is a fascinating subject, and a comparatively new field of scientific investigation. For the reader who is interested, besides the research studies mentioned, the following books are highly recommended: *The Creative Process* by Brewster Ghiselin and *The Act of Creation* by Arthur Koestler. In a related sense, in this chapter and from time to time in the previous

chapters, we have made reference to natural functioning in contrast to compulsive functioning. Besides the psychological writers mentioned earlier, for the reader who would like to pursue the topic in greater philosophical depth, Lewis Mumford's *The Conduct of Life* is highly recommended.

Such topics as the personality of the artist and creativity are certainly a legitimate part of any discussion concerned with the problems of looking at and understanding art today. But in dealing with these topics, it is true, we have digressed somewhat from the subject of art itself. Of course, we feel that such a move is justified. As we begin our next chapter on Abstracting in Art, we will likewise, in a sense, be digressing—at least for a good part of the chapter. Again, we feel that the move is justified. As a matter of fact, we believe that an understanding of the process of abstracting is the main key to understanding modern art.

CHAPTER EIGHT

Abstracting in Art

In our time, the word most often used to characterize modern art is the word *abstract*. Even the person with little knowledge of art will tell you that modern art is abstract, the assumption being, of course, that the art of previous generations was not. When questioned about the meaning of the term, he might say that the modern artist no longer cares to paint "pictures"—he prefers to paint abstractions. When the term *abstract* first came into use, the layman was not certain what modern artists were doing. All he knew was that the objects in their paintings no longer looked real. Artists and critics used the term *abstract* so often that it became familiar to him, too—but only as a word, not as a visual experience. Eventually, a multitude of people added the phrase "abstract art" to their vocabularies without really understanding its meaning. They did not know how an artist *abstracts* or why.

When an artist paints a tree abstractly, he is not trying to put on canvas a mirror image of reality. Nor does he "see" the tree in his mind's eye as the ordinary person sees it in everyday life. In making a painting of the tree, the artist is conscious that he is abstracting and on what level and to what degree. We shall explain this whole process of how and why the artist abstracts shortly, but, for the moment, it is necessary that we again consider abstract art from the viewpoint of the layman.

To understand and appreciate abstract art one must be capable of following the abstracting processes of the artist. There is little relationship between understanding in this sense and simply being knowledgeable about the subject in terms of names, titles, places and dates. The fact that modern jazz is widely understood is proof that the

average person is capable of following a process of abstracting in another area of the fine arts. Of course, historically, as we have mentioned earlier, music did not get "side-tracked" culturally in the way that art did in the nineteenth century. Composers did not commit themselves to Greco-Roman classicism, imperialistic nationalism, and bourgeois sentimentality to the degree that painters did. Nor did anyone expect the composer to copy the sounds found in nature; all agreed that the imitator of bird calls and cat meows was possibly an entertainer of some sort but not an artist. In essence, nineteenth-century cultural patterns allowed for abstract structuring in sound but not in vision.

The point that is easily missed is that the *cultural patterns and traits of a society vitally affect man's ability to handle abstractions of one sort or another—abstractions* ranging from our concepts about the nature of the physical universe (which, incidentally, are often highly abstract) to the way which we interpret what we see.

Today, because of the twentieth-century scientific break-throughs in the fields of anthropology, psychology, linguistics, and semantics, we have a whole new understanding of how human beings communicate, in one medium or another, by abstracting. For example, when we use words, signs, and symbols we are abstracting. Words are verbal abstractions. There are many non-verbal abstractions of one sort or another, such as signs, symbols, and signals. The traffic light is a non-verbal sign telling us to stop or go; the various highway road markers contain symbols indicating a curve or intersection ahead; the various signal devices such as horns, whistles, flashing beacons, and so forth are also abstractions of a non-verbal nature. Mathematics is another abstract and symbolic language. So is music. And so is art.

The kinds of abstracting that take place vary from one culture to another. Using mathematics to illustrate a point: a man from a primitive society, who counts with his fingers and toes, cannot possibly follow us as we use even elementary arithmetic. Yet, this man, as unsophisticated as he is in many ways, is more capable of understanding the highly abstract language of modern art than is the average person in our society. Fundamentally, the art of most primitive societies is abstract rather than realistic. The primitive artist does not attempt to duplicate reality (Fig. 29). Thus, the primitive man has no difficulty in understanding what **Picasso** meant when he said, "Art and Nature are *not* the same thing." Moreover he can react more positively not just to modern art but to most of the artistic output of mankind because it has been, for the most part, *abstract* rather than realistic. The abstracting techniques of his culture make this possible. In other words, he has less difficulty than modern man in following the visual abstractions of other civilizations because they are easily equated with his own.

In a sense, we are what our culture makes us. And, in the same

sense, much of what we are depends upon how we handle the abstractions of our culture. We may safely say that in the realm of awareness there is a symbiotic relationship between the abstractions of a culture and the understandings of a culture. Similarly, vision, abstractions, and art are bound up together. When we look at the world, our eyes are not recording things in all their realistic detail. As we see, we make abstractions of what we see. We accept, reject, or modify what is really out there depending upon our evaluational criteria, which, in turn, are often conditioned by our culture. Depending upon a society's patterns of abstracting, a person can be taught to "see" things that are not actually there or not to see things that are there. For instance, sea monsters were very real to sailors prior to Columbus. On the other hand, today, there are some tribes of primitive people who cannot interpret what they "see" in black-and-white photographs (such photographs are abstract to a degree: they leave out color and depth). And our scientists and technicians see through the telescope, under the microscope, and in everyday life aspects of reality that the average person does not see because he has not been trained to see in that particular sense.

The extent to which our society has "trained' us to see has been graphically illustrated by the laboratory experiments of the scientist and artist, Adelbert Ames. For one of his experiments at Dartmouth, he built a room that is weirdly shaped, having floors, windows, and doors that are not actually "there" in the sense that the observer sees them. Tricks of perspective are used to fool the observer into "believing" that things are near when they are far and that the floors are level and the walls straight, when they are not. It is a cockeyed room and people have a great deal of difficulty adjusting to it. They "see" the room according to their past experiences, not according to what is actually there. In our machine-age culture, we tend to visually orient ourselves to the rectangle. Our streets, buildings, rooms, walls, floors, doors, windows, and furnishings are generally based on rectangular patterns. In familiar settings, we tend to see in terms of these patterns and their accompanying perspective—even when such patterns are illusional. What this proves, of course, is that our senses are not as reliable as we would like to believe and that what we see or what we do not see is often determined by the culture we live in.

In order to survive, we must react satisfactorily to external events. When it rains, we seek shelter; when it freezes, we wear heavier protective clothing. If someone throws a brick our way, we duck—usually! Notice the word "usually." Like other animals, we learn to respond *perceptually* (through our senses). Unlike other animals, we also learn to respond *conceptually*. Thus, if a trusted friend tells us that the brick is made of sponge, we might not duck. We think in terms of abstractions derived perceptually as well as conceptually (verbally and symbolically).

As illustrated by both the case of the sponge and the Ames room, how we abstract, in an ordinary situation, depends on our cultural conditioning.

How then do we abstract? When we abstract, we select, omit, deduct, summarize. Abstracting may be defined as a process of leaving out details. These are the more standard meanings of the term. In addition, as the general semanticist, Alfred Korzybski,[1] points out, and as the Ames room illustrates, in matters of day-to-day survival, our nervous system is continually abstracting. Because of the variety and complexity of the multitude of signs and signals coming in from outside our skins, we are forced to make abstractions to adapt and react to our environment. As our total organism evaluates these many events, signs, and symbols in the real world, some are accepted, some rejected, and some modified, depending upon our personal or inner view of the real world.

As the cultural environment changes, the old habits of abstracting stand in the way of new understandings, interpretations, and concepts. The most obvious examples of this phenomenon can be found in the field of education, from which we shall take one illustration.

Many parents, trained in the mathematical methods of a generation ago, are unable to help their children with the math being taught today. Instead, it turns out that the children, since they are not pre-conditioned culturally, can deal more easily with these new abstractions than their parents, whose reasoning proceeds only along the rails of the old method. In order to learn to handle the new abstractions, the parents first have to discard certain fixed notions (those of the old method) about math. In short, cultural conditioning sometimes has an adverse effect on the ability to deal with abstractions.

From what has been said so far about abstracting (and from what has been said elsewhere in the book), you may have already guessed why many people in our culture fail to follow the abstractions of the artist. Because of past cultural conditioning, both conceptually and perceptually, they expect physiologically to see images that are recognizable in the most literally real sense. The cultural conditioning of the *educated* twentieth-century artist, on the other hand, is quite different. The visual abstractions of most of the other civilizations, such as the Egyptian, the Byzantine, the Gothic, the Renaissance, the African, the Pre-Columbian, the Oceanic, and the Oriental, are a part of his visual language. Like the unsophisticated man from a primitive culture, the modern artist is not only capable of communicating with such art, he is "in tune" with it. Furthermore, these many-varied approaches to visual form have revitalized the modern artist. We can see manifestations of Greek, Oceanic, and African styles in the work of Picasso (Fig. 55); various American Indian styles in the work of Tamayo and Orozco; the Oriental

[1] Alfred Korzybski, *Science and Sanity*, 3rd ed. (Lakeville, Conn.: International Non-Aristotelian Library Publishing Co., 1948).

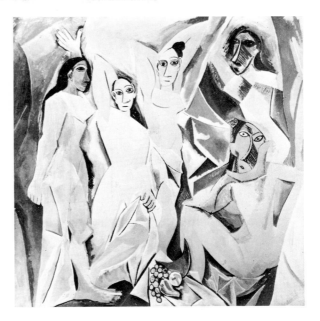

55. Pablo Picasso. *Les Demoiselles d'Avignon.* 1906-07. 96 × 92″. The Museum of Modern Art, New York (Acquired through the Lillie P. Bliss Bequest)

in Gauguin and Matisse (Fig. 49), and the primitive in Miro and Klee (Fig. 54). Because the artist is too knowledgeable visually, and because he puts this knowledge to work as he paints and sculpts, his work is rejected by the philistine. It is by knowing too much that he is unable to communicate.

Until the layman realizes that a painting on a wall is not a picture-window view of the actual world outside, he will not be able to communicate with the modern artist. For communication to take place, the layman must be reoriented; he must understand how and why the artist abstracts. Then, he can arrive at a better understanding of art. And then, he can enjoy it.

Let us return to the situation of the artist painting a tree. As we stated: The artist sees the tree differently from the ordinary person because he is "conscious that he is abstracting and on what level and to what degree." What does this seeing differently consist of? Does he see something different from the physical tree, or does he see the tree differently because of his particular objectives as an artist?

First, we need to consider the appearance of the tree. If we were to ask the average person to describe a tree to us, what would he say? Most likely he would tell us that the tree has leaves and branches and a trunk with bark; he might comment about the height and size of the tree, and so forth. If we were to ask a botanist about the tree, we would expect him to give us a more factual and systematic account. Probably he would describe in great detail the nature of the leaves and the bark and its other organic components.

The artist, on the other hand, would perceive the tree not so much in terms of its everyday appearance or its structure as in terms of its *essence.* He is interested in the tree as an entity, rather than as something to be analyzed.

Second, the artist realizes that whatever he records on canvas can only be *his* visual interpretation of the tree. It cannot be a duplication of the tree. Instead of painting the tree, the artist is painting what he is thinking about as he looks at the tree. He is mentally decoding and transforming what he sees. He is abstracting. In the language of the artist, this is sometimes expressed as *seeking a feeling into the situation.*

Van Gogh's *Wheat Field and Cypress Trees* (Fig. 11) is an illustration in point. In trying to capture the essence of the cypress trees, Van Gogh does not attempt to paint the trees as they "look," but as he feels them. The person who expects to identify with these trees in the representational sense will be disappointed. He will not be able to communicate with the artist because Van Gogh has interpreted the trees *subjectively.* By using a swirling type of brush stroke, Van Gogh makes the trees alive with movement. The trees are animated; we sense them as living, growing entities. And not only are the trees animated. By using the same type of brush stroke, Van Gogh animates every part of the picture: the trees, the field, the hills, and the sky.

This brings us to another point. While trying to paint the essence of each thing, Van Gogh is also concerned with *the completeness of the situation.* We see that not only is each tree an integrated composition, but also that all the elements of the picture are disposed according to a design for the whole composition. The clouds are to the trees as the trees are to

56. Piet Mondrian. *Flowering Trees.* 1912. 25½ × 29½". Collection G. J. Nieuwenhuizen Segaar, Nova Spectra Gallery, The Hague

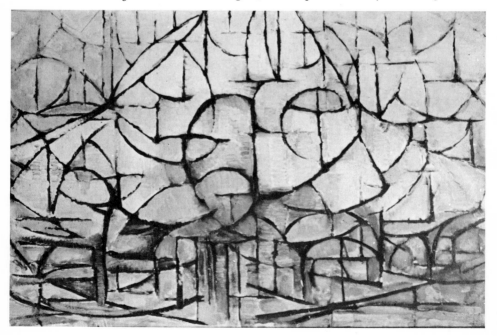

the field, and so on. We may speak of the over-all pattern of the composition.

Now, keeping in mind this idea of integrating individual shapes into the complete picture let us look at a more abstract interpretation of a tree by Mondrian (Fig. 56). This painting makes it apparent that for the painter engaged in the painting process the uppermost thing is not the form of the tree, but the form of the painting. Ironically, we can see that the man in the street is correct: the modern artist *does* prefer to paint abstractions.

Mondrian re-structures the tree. He perceives it in terms of its architectonic structure. In drawing the tree, he gives emphasis to its shape by echoing similar shapes throughout the composition. We become aware of the *structure of the composition* in much the same way as we become aware of all the complex but integrated elements of a Gothic cathedral. It is interesting to point out that the Gothic cathedral is more than just a shelter. It is the embodiment of an idea, the symbol of an age; it is a multifarious abstraction, not just a building. For such reasons, it survives as a work of art, not just as an artifact.

The Mondrian we have just been considering would be classified as a *semi-abstract* painting. Over the years Mondrian worked more and more abstractly until he reached a stage of leaving out all recognizable details (Fig. 5). Such works are called *pure abstractions* or *non-objective* paintings; they will be discussed further in the chapter on Non-Objective Art.

Let us summarize:

First, a painting of a thing is not the thing. In this regard, Alfred Korzybski's reminder would be: "An abstraction of a thing is not the thing; the map is not the territory."

Second, all paintings, including the "realistic" ones, are abstract to a degree: the paintings becoming less realistic as more and more details are left out.

Third, in general appearance, abstractions of different degrees look different. Korzybski would put it this way: "An abstract on one level is not the same as an abstract on any other level."

Fourth, as in the case of Mondrian, an artist can make abstracts of abstracts indefinitely. In this sense, Korzybski points out that: abstracting is potentially continuous.

Just as the Gothic cathedral, with its sculptural and stained-glass images, explained symbolically the Christian faith to the people of the time, the abstract art of the twentieth-century informs modern man about his age.

The new visions of reality revealed by the abstract artist reflect a world in flux: they are *multi-leveled, multi-valued,* and *non-imitative.* As we discuss the modern isms, such as Cubism and Surrealism, in the

chapters that follow, we shall see that, by placing the emphasis on the
play of line, shape, and color, the modern artist encourages the spectator
to think in terms of *process relationships*. The exception to this is the
recently introduced Pop-Art movement. Pop Art is based on the most
elementary level of identification ever attempted in art. For this rea-
son, it is questionable whether a painted, plaster facsimile of a pork
chop wrapped in plio film will, in time, be cherished as an art object.

The objectives of the abstract artist are exactly opposite. By working
abstractly, he reminds the spectator *not* to identify in terms of concrete
absolutes. If the person looking at paintings by such abstractionists
as Mondrian, Picasso, and Klee is the kind who identifies Elizabeth
Taylor with Cleopatra and Charlton Heston with Michelangelo, and
whose mouth waters when he sees an Armour-Star Ham on a billboard,
he will have to change his *habits of identification* before he will
be able to appreciate abstract painting. In the world of art, as in the
film world and the world of commerce, *the symbol for a thing should
not be confused with the thing itself*. The person who understands this
will be able to enjoy modern art. He will have many new worlds to
explore in the realms of human vision, thought, and feeling. For him
the phrase, "Art for Art's sake," will take on new significance.

This chapter on abstracting in art was written to help the layman
look at *all* art but, of course, modern art in particular since it places
great emphasis on abstract factors. In the next five chapters we shall ex-
amine in more detail the major isms of modern art: Impressionism,
Expressionism, Cubism, Surrealism and Non-Objective Art. Also, in
bringing our study of contemporary art up to date, we shall briefly dis-
cuss Op and Pop Art. However, the emphasis in Pop Art is not on
abstract factors: basically, it is a different brand of realism. This brings
to mind several important matters in regard to styles in art that we
should like to clarify before dealing with the modern isms. In the process,
since our approach to art has been topical rather than chronological, we
shall summarize briefly the main period styles in the West since the
Renaissance.

STYLES: FROM THE RENAISSANCE TO THE MODERN ERA

Beginning with the Renaissance, style was the result of the inter-
play of several factors: the individuality of the artist, the locale of the
artist, and the social-political environment of the artist.

In the Early Renaissance there was a shift from the heavenly world
of the Gothic to the earthly world of reality. In Italy, the rediscovery of
the classical world gave birth to Renaissance Humanism. The spirit
of humanism was reflected in the art of the times: there was a return
to classical idealism and naturalism. During the High Renaissance the

work of such artists as DaVinci and Michelangelo (Fig. 21) typified this trend. Yet, because of their strong personalities, their work is quite different in style and treatment (Fig. 8). As artists they are products of the Italian Renaissance, but they are also highly individual. Furthermore, the Northern European artists of the time, such as Grünewald (Fig. 40), Dürer, and Breughel, were less influenced by the classical tradition and their work was considerably more realistic.

The Baroque and Rococo periods extend from the seventeenth to the mid-eighteenth century. Again, the styles vary depending upon personality, place, and environment. For example, such artists as Bernini, Tiepolo, Rubens, Van Dyke, Watteau and Fragonard typified the Baroque or Rococo styles. They all painted for the aristocracy; their work stressed gaiety, grace, and elegance. Their styles were exuberant, colorful, vigorous, and sometimes opulent and extravagant (Fig. 57). Their compositions are dramatic and complex, stressing movement and deep space. Yet, their individuality is easily recognized.

At the same time there were two other styles, less typically Baroque. Latour, Poussin, and Lorrain carried on in the classical tradition. They too painted for the aristocracy, but their work stressed order,

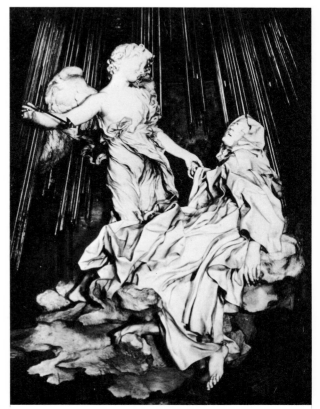

57. Gianlorenzo Bernini. *The Ecstasy of St. Theresa.* 1645-52. Marble, lifesize. Cornaro Chapel, Sta. Maria della Vittoria, Rome

formality, and restraint. Their figures and landscapes were idealized. Latour's approach to form was monumental and generalized but patterned in a quite modern fashion. Poussin's forms were architectonic, anticipating Cézanne. Lorrain's lyrical and poetic treatment of form was more subjective, anticipating the romanticism of Géricault and Delacroix.

The great realists of the period were Rembrandt, Hals, Vermeer, and Chardin. They painted for the wealthy as well as the new middle-class. They painted ordinary people engaged in everyday activities: cooking, eating, drinking, sewing, reading, and so forth. "Genre" and "local color" are terms describing realism of this sort. What made the realism of these artists distinctive was their concern for composition and painterly factors as well as their sincerity and truthfulness (Fig. 36). Their realism was the antithesis of what has been called flamboyant baroque (Fig. 57).

Beginning with the last half of the eighteenth century, as a result of the social and political changes brought about by the philo-sophers of rationalism and the French Revolution, there was a dramatic shift away from the more flamboyant baroque toward the classical. The French painters David and Ingres personified this Neoclassical style. Essentially, the new political ideologies of the time were lauded in the allegorical paintings and sculptures of the classicists (Fig. 33). A formalized Neoclassical style became the official national style of France with appointed academicians dictating policy.

Countering trends were realism, naturalism, and romanticism. Two great realists of the time were Goya (Fig. 41) and Daumier (Fig. 26); two great naturalists were Constable and Corot; two great romanticists were Géricault and Delacroix. All these painters were more painterly. The realists and naturalists painted the everyday world; the romantics depicted adventurous themes from history, and exotic subjects. Regard-less of the school, the artists we have mentioned were all cognizant of form, whereas the lesser artists of the time—those who produced the endless potboilers, were overly concerned with finish and story.

CHAPTER NINE

Impressionism

Out of Impressionism a new world of art emerged. In order to understand art today, one must begin with what took place a hundred years ago when the Impressionist movement began.

Impressionism—truly a revolution for the artist—was launched by a handful of daring young French painters: Monet, Pissarro, Renoir, Sisley, Degas, Berthe Morisot, and others. After working together for several years, they held an exhibition in the early 1870's. Because their work was a marked departure from the official academic salon art of the time, the public was outraged: it considered the exhibit an insult to its taste. As a consequence, in writing a satirical review of the exhibit, a journalist insultingly called the exhibitors "Impressionists." The label he had given them was taken from the title of a canvas by Monet, called "Impression Sunrise." The writer used the term because Monet's painting appeared to be unfinished, hardly even a sketch, for that matter. To him, it did not *deserve* to be called anything except—an "Impression." Being independent and flaunting the intent of the art critic, the group accepted the name—a name which eventually became synonymous with the birth of modern painting.

Unfortunately words cannot explain paintings. The word Impressionism does little to describe this style of painting or what these artists intended. Perhaps a more appropriate label would have been "The New Painting." Nevertheless, the word was coined and, along with other labels for styles of painting, we're stuck with it. Now, in what way did this new painting differ from the old painting?

In the years preceding Impressionism, the traditional approach to art called for painters and sculptors to select themes derived from classical mythology (Fig. 32) or from the strong nationalistic impulses

of the times. Paintings showing "The Flight of Icarus" or "Napoleon Reviewing His Troops" were produced by the hundreds. If local surroundings or contemporary life were to be depicted, the subject matter was expected to conform to the bourgeois tastes of the day. This new middle class loved paintings that were assuringly realistic or that told stories of one sort or another. And, as we have pointed out earlier, these stories were usually steeped in the most maudlin sort of sentiment. The important soldiers, statesmen, and explorers were all courageous, handsome, and daring. The important women were nothing short of ethereal. Furthermore, there were no juvenile problems in those days: all the sweet, plump, little kiddies were busy floating on clouds—if we believe what we see in the popular paintings of the time.

Impressionism was a revolt against all this; it was a revolt against a set of rules: restrictions on choice of subject matter, restrictions on rendering techniques, restrictions that hampered the artist's freedom to think and to create. The "brown sauce" paintings of the day, falsely heroic, cheaply sentimental, colorless and lifeless, offered no avenue of opportunity for any artist who loved to paint and wished to communicate.

The Impressionists were active and dynamic painters. Unlike most of the contented academicians of the time, who stayed in their garrets rehashing the old formulas, the Impressionists were "on-the-spot" painters. With brush, canvas, and easel in hand they went to the city street, parks, river banks, ocean beaches, and countryside, seeking fresh views of life. In such settings, painters like Monet, Pissarro, and Renoir attempted to capture the dynamic effects of reflected sunlight on water and foliage (Fig. 34). Basically, their interpretation of reality was centered around light. But, of course, what was eventually to become a completely new style of painting was not something that was born in a vacuum.

In revolting against the norms of the French academicians, these painters had most certainly been influenced by the rebellious spirit as well as the vigorous brush technique of their beloved predecessor Manet. And before Manet, of course, there had been the never to be forgotten giant, Delacroix. They had also been inspired, to a degree, by other more recent predecessors: some of the landscape painters of the Barbizon group, including the realists, Courbet and Corot. But it was the open-air paintings of Constable and Turner (Fig. 12) in England that really set them afire.

After discovering a new kind of directness and freedom in the work of these two Englishmen, they soon carried over to trees, skies, buildings, and people, the short brush strokes of broken color that they had previously applied to the colorful waterways. The total area of the canvas became a pattern of brightly colored broken-brush strokes.

The old ways of modeling form through shading and blending, as well as the concern for precise detail, became subordinate to the idea of the over-all composition.

The Impressionists were concerned wth capturing the sensation of light as it is reflected off objects. They were concerned with painting the allover color tone of the object rather than modeling the object by means of traditional drawing and chiaroscuro techniques. Line as outline or contour was omitted along with dark and light shading. Since it was by means of color that light and shadow was to be captured, they used what has been called, a "rainbow palette." In many of the paintings (but not all) color was applied in tiny dabs of pure color with the eye (the spectator's) doing the blending. No attempt was made to cover all of the canvas with paint, nor was there an attempt to conceal the brush stroke or the textural quality of the paint (Fig. 34). It was a new kind of painting: more poetic, more dynamic, more *painterly,* and less literal, formal, and static. Furthermore, since the camera had just been invented, new and informal ways of composing pictures were suggested to the Impressionists because of the impact of snapshots. An unorthodox view of a scene was refreshing; a scene that was cut off unexpectedly was dynamic.

Being painters in the "natural" sense, the Impressionists were, in essence, interested in painting in what could be called a "motif" derived from what they *saw.* They weren't concerned so much with telling stories, painting things in realistic detail, or creating the illusion of deep space, as they were with emphasizing the *pattern* made on the canvas by paint and brush. It was the poetry of pure painting that they had discovered. Consequently, the era of Impressionism was an era of rapid departure, experimentation, innovation, and emancipation for the artist.

In the early days of the movement, before their fifth exhibition in 1880, the Impressionists approached their work pleasurably and spontaneously. They were not seeking formulas or advocating theories; some of the greatest Impressionistic canvases were painted during that time. But Impressionistic painting, as it was developing, became a new technique, and because people seem to demand rules, programs, and terminology, attempts were made to systematize and compartmentalize the movement. Some of the artists themselves fell victim to this tendency and what, in the beginning, was a living experience eventually became a creed. Parasitically, literary philosophies and scientific principles became a part of what was once a fresh approach to painting. In time, some members, because of their individuality, defected, and others more or less stagnated.

Besides the negative effects of attempts to systematize, Impressionism had other limitations. Drawing and form, as they involve

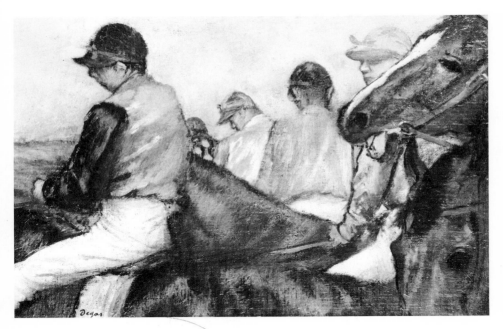

58. Edgar Degas. *Horses with Jockeys*. Oil on canvas, mounted on cardboard, $10\frac{3}{8} \times 15\frac{11}{16}$". Yale University Art Gallery, gift of J. Watson Webb, B.A. 1907, and Electra Havemeyer Webb

59. Paul Cézanne. *Fruit Bowl, Glass, and Apples*. 1879-82. $18 \times 21\frac{1}{2}$". Collection René Lecomte, Paris

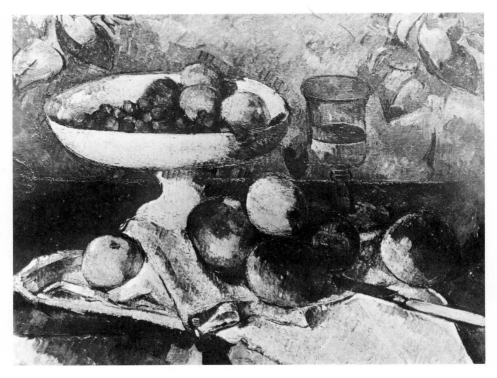

structure, were often sacrificed for the sake of color and pattern. Moreover, the incandescent broken-brush stroke technique did not lend itself well to certain approaches to subject matter; it also imposed a restriction on individuality. As a creative movement, Impressionism flourished for approximately ten years. Afterwards, many of the great innovators of the movement—Monet, Renoir and Degas—moved on to develop their own individual styles.

Monet, in his Rouen Cathedral series and his waterlily series, invented free abstract patterns that anticipated Abstract Expressionism by half a century. Renoir synthesized the rainbow palette of Impressionism with the formal values of classical painting, to paint a series of female nudes that were not only classical and monumental but sensual and poetic as well. Likewise, but in his own way, Degas remained truer to the spirit of draughtsmanship than to Impressionistic tonality (Fig. 58). Yet, considering his use of color and pattern as well as his intimacy and informality, he never completely abandoned the Impressionist point of view. Most significantly, however, Impressionism gave birth to a new generation of highly individualistic painters: Cézanne (Fig. 59), Gauguin, Lautrec, Seurat, and Van Gogh (Fig. 17), to name a few. Because one label would not fit their autonomous styles, they were called the *Post-Impressionists.*

With Impressionism the "new way of painting" began. The Impressionists opened many doors. They gave us a fresh look at nature: we saw it in a new, dynamic, and colorful way. It was truly a *new* kind of seeing. Artists began to do more experimenting with techniques and they were liberated from the many restrictions on subject matter. The artist was free to "paint" again; he was allowed to seek his individuality and freedom.

Since the era of Impressionism, the painter has become all the more creative and exploratory. Much of what the artist has today, he owes to the Impressionists—and he knows it. They are the heroes of modern art.

CHAPTER TEN

Expressionism

Expressionism is not really new, although the term, as it is used, is a twentieth-century one. Expressionism is, in a way, the exact opposite of Impressionism: its starting point is a subjective one, whereas Impressionism is objectively visually oriented. Impressionism is light-hearted, gay, and comparatively unemotional; Expressionism is brooding, soul-searching, and intensely emotional. The Impressionists concerned themselves with the look of things at particular times and under certain conditions; the Expressionists are not at all concerned with how things look outwardly but how things feel inwardly. In a letter to his brother Theo, Vincent Van Gogh wrote: "I am not so much concerned with how hands look but with the feeling of hands." Expressionists paint from the inside out, not from the outside in—they paint subjectively. They do not just paint from the heart—like Rembrandt, modern Expressionists paint the heart pain of mankind—often with raw and jarring courage. In everyday language, the Expressionists paint from the guts. If these seem like strong words, *look* at the paintings of Van Gogh— he had guts! And if you study his work long enough, you will learn to love him for this reason.

Van Gogh's work is courageous and tremendously honest; he pulls no punches. With Van Gogh you will step into a highly individual world. It is a world that thousands of people have been able to communicate with and to understand, but it is, at the same time, a highly subjective world. Modern Expressionism begins with Van Gogh. He sets the mood. At the turn of the century, he was followed by such artists as Munch, Kokoschka, Ensor, Nolde, and Rouault. But it is with Van Gogh that Expressionism can be best identified.

Van Gogh's emotions were released through his art. He painted

vigorously and passionately, with rich color and a loaded brush. The world he depicted was a highly personal one: to him, nature was beautiful but fierce, competing for life under a radiating sun and pulsating stars. Plants and trees quiver with growth (Fig. 11); the air is electrified and streaming with energy (Fig. 17); and people are toil-worn and lonely with despair. Van Gogh did not attempt to paint scenes as they are ordinarily seen; rather he painted his inward reactions to these scenes and events. In this sense, Van Gogh delved *beneath* the surface. This is what Expressionism deals with; it is the world of the inner eye. It is not the world as the artist sees it, but as he *experiences* it.

It has been claimed that Expressionism stems from the Northern European environment where the elements are more harsh and where, at times, life has been bleak. It is true that modern Expressionism had its origin in the lowlands of Europe. It is also true that, much earlier, such expressionistic artists as Grünewald (Fig. 40), Dürer, and Rembrandt came from the same area. Furthermore, Expressionism is often described as being Gothic in spirit—not the soaring Gothic of the stained-glass windows but the haunting Gothic of the gargoyles. But in going back through the past we can find artists making subjective, expressionistic statements almost everywhere.

During the Italian Renaissance we find such statements in some of the sculpture of Donatello (Fig. 52), in the late work of Botticelli, and in Michelangelo's *Last Judgment* (Fig. 21) panel, as well as in much of his sculpture. In the Venetian School, we can find expressionistic statements in the paintings of Tintoretto and El Greco (Fig. 47). In Spain, we find them in Goya's *Disasters of War* series; in France, with such individualistic artists as Daumier (Fig. 26), Rousseau, and Rouault (Fig. 20); in America, with Ryder and, more recently, with Shahn and Graves; in Mexico, with Orozco (Fig. 60), and Tamayo. So, as a movement, it is new and it is not new. And it comes from Northern Europe—but not always.

Because the Expressionists work intuitively and subjectively, their personal styles always vary. For this reason, it would be impossible to categorize Expressionism by way of a style or a technique (such as Impressionism). Expressionism does not grow out of a technique; it grows out of a state of mind. Primarily, it is a reaction against the machine age and the materialism that goes with it. It is a return to the intuitive, the spiritual, and the self. The works of such modern writers and philosophers as Dostoyevsky, Ibsen, Nietzsche, Kierkegaard, and Kafka best express this state of mind in the literary vein.

There are certain mannerisms that can be found in Expressionist paintings. Expressionists paint dramatically, dealing with all degrees of depression and happiness. Things seen are distorted or exaggerated—often in the most shocking way. Color is sometimes intensified, some-

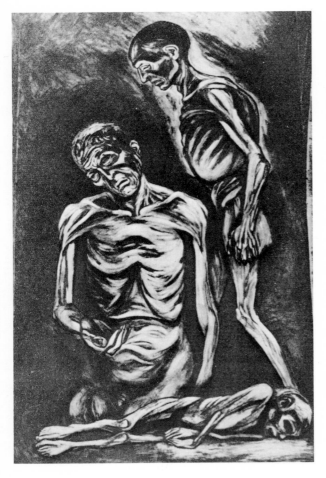

60. Jose Clemente Orozco. *Victims* (detail from a mural cycle). 1936. University of Guadalajara, Mexico

times subdued, it is always used psychologically or symbolically—never literally. The texture—the paint quality—is often heavy and thick, being applied vigorously and passionately. Hesitation and lack of determination are characteristics foreign to Expressionism.

One group of painters related to the movement was the *Fauves* or "Wild Beasts." Led by Henri Matisse, they used color in daring and striking ways; colors once considered to be clashing were used in new combinations—effectively. The color of the *Fauves* was not used to "identify" but to "express." Blueness, for example, would refer to the *mood* of the painting, not to an *area* designated as sky.

Another group formed a federation called *Die Brücke* (The Bridge). As painters, they were concerned with the religious, sexual, social, and political injustices of the times. Dealing with the environmental tensions of the day, they used a form of expression that is direct, childlike, naive, and primitive. Edvard Munch's famous painting, *The Scream* (Fig. 31), is a typical example of their approach. *The Scream* is carried by the linear pattern made up of curving lines which move

outward from the figure into the sky. These lines seem to flow and vibrate, and the echo of the cry is almost heard through the direct feeling-impact of the linear pattern.

A third group of painters called *Der Blaue Reiter* (The Blue Rider) dedicated themselves principally to the spontaneous and creative release of feeling. They were not concerned with the old mannerisms, the old compositional theories, and the like, but with the desire to create new forms. From this movement, through such artists as Marc, Klee (Fig. 54), Kandinsky, Chagall (Fig. 48) and Miró, there is a line leading directly to the Abstract Expressionism of today, made famous by such artists as de Kooning, Pollock (Fig. 4), Kline, Hartung, and Soulages. Thus, Expressionism, like Impressionism, was a release for the artist, and its liberating effect is being felt to this day.

CHAPTER ELEVEN

Cubism

Cubism, like Impressionism earlier, was a major breakthrough for the modern artist: *all* of the old barriers were broken down. Although the history of Cubism is a complex history of rapid and dramatic changes in style, its main function was to establish for the artist the unequivocal right to structure his subject to suit the picture rather than the other way around. Thus, the plastic elements (line, shape, color, texture) become fully plastic; they can be manipulated without restraint if the result is a picture that holds together from the standpoint of structure in the sense that a bridge or a building holds together.

In this sense the Cubists owe almost everything to the pioneering work of Cézanne. Without knowing it, he was their teacher. But they continued his modulations of the plastic elements until the object became completely subordinate to the form of the picture: the picture became *truly* the thing in itself.

Cubism is a visual language that is quite unique. It is based on a perceptual rationale that is related to Cézanne's modulations of form, space, and color. And the way Cézanne manipulated these things is something that must be *seen* to be comprehended. As Cézanne's approach is discussed, bear in mind that these brief explanations are oversimplifications and that Cézanne himself had great difficulty trying to explain what he was about.

Cézanne's Approach

If Cézanne were painting several buildings, he would not hesitate to show these buildings from several different "eye-level" or perspective views in order to make them "feel" more solid. He would do the same thing when painting a still life (Fig. 59). If, in one of his paintings,

94

you were to see the silhouette of a bottle on a table, a bowl on the same table would most likely be tilted down slightly to allow you to sense the inside volume of the bowl. Furthermore, the shape of the bowl might be slightly distorted so that it would not appear to come forward too much and thus pop out of the picture. In this same sense, too much of an illusion of deep space can be disturbing. To counteract this effect, Cézanne would modify the spatial elements by introducing compositional devices which visually reduced the depth of the picture. In a landscape, for example, distant objects would appear distant but would also harmonize structurally so well with objects in the foreground that the space between was inconspicuously compressed.

As a part of this concern for a compressed "picture-box," Cézanne would also manipulate color. In a Cézanne landscape, colors in the far distance are as bright as colors in the foreground. In Renaissance style paintings, things in the far distance are painted hazier and bluer. This effect often causes the paintings to be out of balance from the standpoint of color, with the sky areas often pale and weak compared to the foreground. Cézanne's use of color not only helped to compress the picture-box, but it also unified the entire composition by better color balance.

Shapes were also modified by Cézanne if the modification helped to improve the composition. For example, he would draw a table so that one side might not exactly fit the other side but the shapes or the spaces involved would be more varied and less monotonous than otherwise. Cézanne was as much concerned with the beauty of the shapes or spaces between things as he was with the shapes of actual things. Thus, in artistic terms, from the standpoint of design, the *negative space* becomes as important as the *positive space*.

As a part of his way of stylizing, Cézanne painted with a kind of parallel brush stroke technique, and the shapes of his buildings, bottles, and figures were drawn somewhat geometrically. He stylized in this way because he was searching for an art that had solid structure. In a letter to a young artist, Emile Bonnard, he said ". . . Treat nature by the cylinder, the sphere, the cone . . ." For the modern artist, this statement was literally "the cannon shot that was heard around the world." His interpretation of the visual structure of things undoubtedly gave direction to Cubism. Yet, to the layman today, Cézanne's work appears to be realistic, whereas Cubism appears to be strangely abstract and far from realistic. Nevertheless, the compositional manipulations of Cézanne gave the Cubists their starting point.

THE APPROACH OF THE CUBISTS

In some of the first Cubistic landscapes, Picasso and Braque geometricized buildings, trees, and land forms to extreme. Shape and color were also modulated to a much greater extent. Because of the geo-

metrical appearance of these paintings (Fig. 55), a critic, much in the derogatory manner of the critic who gave the Impressionists their label, called these paintings Cubistic. This too is an unfortunate label because it confuses the layman. Naturally, he expects to see something solid, like a cube—but actually, as Cubism developed and evolved, the shapes of things depicted became more and more flat in appearance. To him, most Cubistic paintings are "flat" paintings, just as Egyptian, Byzantine, and Oriental paintings are flat paintings.

THE CUBISM OF PICASSO

As one of the innovators of Cubism, Picasso was primarily influenced by his immediate predecessor Cézanne; but he was also influenced by a change in the artistic environment of the time: the introduction of African sculpture to Europe. As Picasso developed his particular Cubist style he made a rationale out of these two styles. This brings up a point.

Nothing is any more *completely* new in art than in anything else. Henry Ford did not invent something new when he made his first car; he simply gave some old engineering principles a new twist. Noted for his eclecticism, Picasso did the same thing for Cubism. This was his contribution as an inventive artist. Nor is this to Picasso's discredit. The ability to combine the dissimilar in order to create the new is a characteristic of most creative people. In this vein, although people have been riding bicycles and watching bullfights for years, it was Picasso who made an "art object" out of a bicycle seat and handle bars: *The Head of a Bull* (Fig. 61).

61. Pablo Picasso. *Bull's Head.* 1943. Handlebars and seat of a bicycle. Galerie Louise Leiris, Paris

The painting *Les Demoiselles d'Avignon* (Fig. 55) clearly illustrates the influence of African sculpture on Picasso. Although most of the painting shows geometricization, the faces on the two figures on the right of the picture are stylized along *primitive* lines. Again and again, during his career, Picasso returns to this primitive source. The paintings he made during the Spanish Civil War and World War II, including the *Guernica* (Fig. 7) mural, derive much of their power from the impact of primitive stylizations.

THE EVOLUTION OF CUBISM

As Cubism developed between 1907 and 1914, artists such as Braque, Léger, Delaunay, Lhote, and Gris painted familiar objects, such as bottles, wine glasses, fruit bowls, newspapers, musical instruments, and playing cards, as well as people—all seen from different eye-level views. The use of such multiple vantage points (to an extent far greater than anything Cézanne had done), called for a new way of handling space. These multiple images were superimposed upon one another. Typically, a part of one object would be drawn so as to appear to pass through another object and both objects would be rendered transparently to capitalize on the effect. *Interpenetration, juxtaposition,* and *counterchange* are terms used to describe these cubistic techniques. As an additional surprise, in some cases, pieces of paper and cloth were actually pasted right onto the paintings. *Collage* is the word used to describe this technique.

The early stage of the movement was called *Analytical Cubism.* Picasso and Braque especially resented this term because they considered painting an intuitive process. Essentially, the term was used to contrast this early stage of the movement with a later stage introduced by Juan Gris, called *Synthetic Cubism.*

Instead of starting a composition by looking at the object and analyzing it, Gris would first build an abstract structure out of line, shape, and color and *then* arrive at subject matter. This is a more imaginative way of starting a painting and one that has become increasingly popular today, especially in the field of *non-objective painting.* Such an approach to painting can be compared to ink-blot testing in the field of psychology: *the image suggests the idea.* Searching for a motif through abstract shapes is not new. During the Renaissance, Leonardo da Vinci spoke of the process when he wrote in his *Treatise on Paintings*:

> You should look at certain walls stained with damp, or at stones
> of uneven color. If you have to invent some backgrounds you will
> be able to see in these the likeness of divine landscapes, adorned
> with mountains, ruins, rocks, woods, great plains, hills and valleys
> in great variety; and then again you will see there battles and

strange figures in violent actions, expressions of faces and clothes and an infinity of things which you will be able to reduce to their complete and proper forms. In such walls the same thing happens as in the sound of bells, in whose stroke you may find every named word which you can imagine.

Later on, in the footsteps of da Vinci, artists such as Rubens and Delacroix made small sketches of an abstract nature as a means of getting compositional ideas going. With Synthetic Cubism, however, this way of working becomes an end in itself for the first time.

FUTURISM

Stimulated by the completely new mannerism of the Cubists, a group of Italian artists known as the Futurists introduced an additional concept to painting: movement in "space-time." The idea of depicting movement was not new to painting; paintings of horses running, people walking, trees bending, and waves rolling were commonplace.

Early Renaissance artists would show the same person several times and in several places in a painting if they wanted to tell of a sequence of events. The Impressionists painted busy street scenes with broken color to give the impression of movement. But the Futurist approach was more Einsteinian: simultaneity and fusion—movement as a process—epitomized their approach.

Visually, the Futurists broke new ground: as they saw it, a walking dog, for example, had multiple feet and multiple tails. In addition, it wavered as it walked. Balla's famous *Dog on a Leash* was such a painting. Thus, it was their goal to capture the dynamic sensations of movement.

They further felt that the effect of light on motion would tend to visually de-materialize a moving body. Although Marcel Duchamp is not classified as a Futurist, his famous *Nude Descending a Staircase* (Fig. 50) is a classic example of such a concept. In Duchamp's painting we not only do not see a "nude," we hardly see a figure at all. By means of geometric shapes and multiple edges superimposed in a cubistic manner, we simply feel the *sensations* of a "figure" descending some "steps." It is ironic that when this painting was first shown in this country in 1913 at the now famous Armory Show, Americans were aghast; today, however, our magazines are saturated with advertisements done in a similar manner. A person reaching for a telephone, an automobile tire going over bumps in the road, and jet airliners taking off are familiar examples. Today, in magazines, the sport enthusiast "sees" how the pitcher winds up or the pass was completed by means of multiple-exposure photo techniques. Yet, too few sport fans appreciate the fact that this new way of seeing was first presented by the painter not the photographer. In this

vein, the architect Frank Lloyd Wright once said, "maybe this is the way creative ideas are handed down—not through emulation but through imitation." If so, it is unfortunate for our civilization. People should be capable of accepting art directly, not second hand. In every one of the so-called "golden ages" of the past, people have been able to live with art in the immediate sense. Such a capacity seems to be a measure of eras of significant human achievement.

THE INFLUENCE OF CUBISM

Cubism has had a tremendous influence on our lives. Architectural designers, interior decorators, textile designers, animated cartoonists, and advertising artists owe many of their ideas to the inventiveness of the Cubists. Today, a commercial artist unfamiliar with the stylizations of Cubism would be unable to find a job. Cubism has been with us in this vital sense for over half a century. People in the arts know it; the man in the street is saturated with it without being aware of it—to the extent that he still laughs off such stylizations when he sees them in an easel painting. Such behavior is, of course, astounding and people are rather dumbstruck when they conscientiously search for Cubist mannerisms in consumer design for the first time: there is no end to the influence.

With Cubism, the old ways in art were truly abandoned; the form of things was broken down and rebuilt. The world of vision was transformed; imagination broke loose. Modern man found a visual language compatible with the new technological world of the twentieth century; the motif of modern times became fashioned after Cubism. The constantly changing forms in the real world met their match in the pictorial manipulations of the Cubists.

CHAPTER TWELVE

Surrealism

In general, Surrealism, as a movement, has been successful in the popular sense primarily because it is less abstract in form than any of the modern isms discussed so far. Although the objects depicted by a Surrealist may be weird or fantastic in appearance, they are usually rendered in the three-dimensional style inherited from the Renaissance. The style of Salvador Dali is the most typical example of such an approach. In Surrealistic paintings, the landscape or setting may be dreamlike or otherworldy, but since the rendering is realistic, recognition is no problem. Therefore, the paintings make sense to the average person. And because, as always, people are fascinated by the weird and the fantastic (especially when they can see it), they take the time to look at Surrealistic art whether they understand it or not.

Furthermore, because modern man has a new appreciation for the world of psychology and, especially, psychoanalysis, Surrealism has an intellectual appeal. Since Surrealism is directly related to Freudian psychology, with its emphasis on the subconscious and dream association, people study Surrealistic paintings out of curiosity.

Surrealist art also satisfies the demand for content. Surrealism is quite literary. It tells a story or it has a message. But what it has to say is often cause for mixed reactions in the modern audience. Surrealism is loaded; it affects people in the most vital sense because it deals primarily with the pressing psychic loneliness of twentieth-century man.

Modern man's dilemma—his capacity to do evil as well as good; to destroy as well as build; to be lonely as well as happy in the machine age —is at the heart of the matter. This new kind of loneliness, this new kind of contactlessness, is what, in Freudian circles, is called the "neurotic syndrome." Surrealism speaks about this condition.

As a matter of fact, Surrealism had as its beginning the dilemma of the First World War. This war had monumental significance. It made little sense: God and Justice were on both sides. It was crazy: trench warfare, gas warfare, and mechanized warfare proved to be completely mindless. As a result, western man, with his ability to reason and his concept of progress, was set back on his heels. Moreover, the war foretold more horrendous things.

Since artists are vitally concerned with and affected by their time, there were reactions in the art world. These reactions were at first, as could be expected, completely nihilistic. The Dada movement was the first of such reactions. A few years later, this essentially negativistic movement gave birth to Surrealism, which was more positive.

Dadaism was not so much a movement as a state of mind brought on by the death, destruction, and disillusionment of the war. A product of despair, it was a point of view that was unequivocally anarchistic. The word "Dada," as it was used, signified the meaningless babble of an infant. The Dadaists dedicated themselves to a new form of art for the new age of pessimism—an anti-art.

The Dada poets wrote "idiotic" poetry, the artists made crazy combinations of odds and ends and called them "ready-mades." Thus, pictures were made out of rubbish, scandalous objects such as urinals were exhibited as sculpture, and everything was debunked—especially the "machine." Art itself was discredited; even the Mona Lisa was copied and painted with a mustache. Thus, the Dadaists set out deliberately to shock their audience. There is no better example of the kind of effect a Dada art object has on the viewer than Oppenheim's *Fur-Lined Teacup and Spoon,* A creepy sensation, to put it mildly, is caused by seeing such an object. And, the tactile sensations that are experienced out of the incongruity of the thing border on the nightmarish or morbid.

As artistic anarchists, the Dadaists were dedicated to the slogan, "Destruction is also creation." In a sense, they were right, because out of this negative response to the machine age a new kind of imagery was formed. And with Surrealism, imaginative art came truly into its own.

True, imaginative art was not new. Hieronymus Bosch (Fig. 24) and Pieter Breughel painted the paradoxical world of the nightmare during the early Renaissance. El Greco's religious scenes have a mystical haunting quality (Fig. 47). Goya created fantastically evil and morbid creatures (Fig. 25). Many of the Romantic painters of the eighteenth and nineteenth century, such as Boecklin, Fuseli, Blake, Moreau, Rousseau, Redon, and the Americans, Cole and Allston, painted fantasies. But Surrealism is a product of the twentieth century; it could only come out of *modern* nightmare.

Surrealism, like Dadaism, had literary origins. The word itself was coined by the French playwright Apollinaire, for the title of a play. It was next borrowed by the poet and critic André Breton to describe a

kind of automatic writing he was experimenting with. Breton was greatly influenced by the work of Freud and hoped, by writing spontaneously and without reticence, to release the stream of the subconscious. The next step was to apply the term to the kind of painting being done by some of the more positive Dadaists: de Chirico, Hans Arp, Max Ernst, and André Masson. By 1924 Breton had published a Surrealist manifesto, defining and giving direction to the movement. The emphasis now was to be completely Freudian; pure psychic automatism or free association was the new means for the artist to get at the hidden essence or truth of things. Dream associations and the like, released from the subconscious or unexplored realms of the mind, could provide an endless supply of new themes for the artist.

By putting dream content to work and by searching for the unexpected in all sorts of shadowy marks and shapes and rubbings, the Surrealists revealed a new world of fantasy and nightmare. Surrealistic paintings are often morbid, sometimes visionary, usually shocking, but *always* paradoxical.

De Chirico paints haunting landscapes containing solitary figures and strange, coldly pure buildings. Feelings of anxiety, silence, the classical, and the metaphysical are conveyed (Fig. 37).

Delvaux paints lyrical moonlit towns and rooms inhabited by people who seem to be walking in their sleep, some fully clothed, some completely naked. There is a sense of timelessness.

Dali stretches shapes and forms as though they were made of rub-

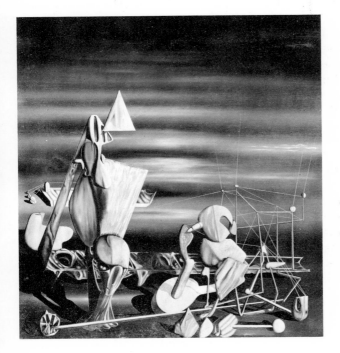

62. Yves Tanguy. *Slowly Toward the North.* 1942. Oil on canvas, 42 × 36". Collection, The Museum of Modern Art, New York (Gift of Philip C. Johnson)

ber or melting soft plastic. Watches bend and become limp; spoons stretch to the far horizon. People are morbidly contorted and everything is set in vast, da Vinci-like landscapes.

Tanguy creates weird forms that appear to emerge from vast, deadsea bottoms. The air is gaseous and a weird light prevails over all. It is an outer-planetary vision. (Fig. 62).

Tchelitchew depicts people as though seen through X-ray eyes. Internal organs, membranes, and blood vessels are revealed and all of this organic matter seems to glow with a strange luminosity.

Chagall, on the other hand, is the happy fantasist who paints scenes from the dreams of his childhood (Fig. 48). Folklore, fairytale, and innocent love are his usual themes. Chagall's style of rendering is somewhat Cubistic and, although it is safe to call his work Surrealistic, it does not have the usual three dimensional perspective of most paintings in this category.

Actually, it is often hard to draw the line when we use such labels as Impressionism, Expressionism, Surrealism, and Cubism. Often, in the work of an artist, the isms overlap (Fig. 48), for after all, an artist is bound to be affected by all of the mannerisms and ways of seeing of the present as well as the past. It is well to remember that we can separate things with words, but words are not paintings.

Likewise, the paintings of Klee (Fig. 54), and Miró are a blend of Surrealism and Cubism. Both conjure up poetic, primal images, embryonic forms, and rudimentary figures that must be seen to be described. Both artists manage to evoke feelings of childlike innocence coupled with the irrational. Both have highly individual styles.

No discussion of the Surrealistic movement is complete without considering the inventive contribution of Max Ernst. Ernst was one of the most dedicated Surrealists. He was especially interested in discovering the unexpected. With this as a goal, he invented the technique called frottage, a technique that can be pictorially equated with automatic writing. A frottage is made in the same way a child makes a pencil rubbing from a coin, only the artist makes rubbings by placing the paper over such things as wood, fabric, leaves, rocks, and other objects. Through a close examination of the impressions made by such rubbings, many strange and bizarre shapes are revealed.

Ernst capitalized on this technique. With the help of frottage, his imagination took fire. His paintings are a storehouse for the bizarre, the fantastic, and the irrational. His paintings are animated with insect, animal, and human forms that emerge from plants, rocks, and shadows (Fig. 63). Furthermore, he used the technique of collage in a way different from the Cubists. In his collages disparate things are combined. Out of the combination of these contradictory images new things are

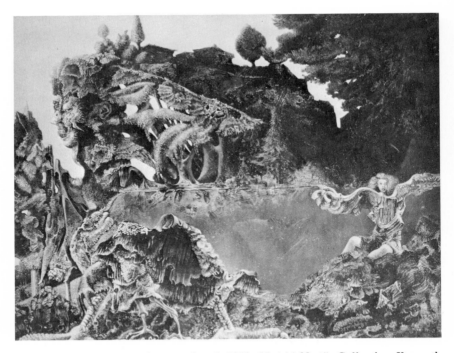

63. Max Ernst. *Swamp Angel.* 1940. 26½ × 32½". Collection Kenneth Macpherson, Rome

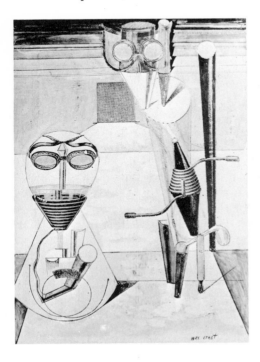

64. Max Ernst. *1 Copper Plate 1 Zinc Plate 1 Rubber Cloth 2 Calipers 1 Drainpipe Telescope 1 Piping Man.* 1920. Collage, 12 × 9". Collection Hans Arp, Meudon, France

created: a human being might be given an animal's head, or a human might be turned into a light bulb (Fig. 64).

In applying the techniques of frottage and collage to painting, Ernst considered himself to be a spectator witnessing the birth of his paintings. He called himself a blind swimmer; by inducing clairvoyancy he could see.

In conclusion, Surrealism, like Dada, is not so much a school of painting or a technique as it is a state of mind. The impact of the two World Wars and Freudian psychology set it in motion. And, as a movement, it will be adrift as long as men dream.

CHAPTER THIRTEEN

Non-Objective Art, Op, and Pop

NON-OBJECTIVE ART

With non-objective art we come full circle. We are back to the basic problem again, that of appreciating form. Non-objective art has no content; it is *pure form*. The non-objective artist is not concerned with telling any kind of story in the literal or narrative sense. In a non-objective painting, there are no objects or symbols of objects to identify with: no people, no buildings, no trees, no sky, no sun, no moon—there are no recognizable objects of any sort. There *is* feeling—conveyed through the form.

By making maximum use of only the *plastic* elements (line, shape, color, and texture) an empathic message may be conveyed non-objectively. Although this idea was introduced in the chapter on Evaluating a Work of Art, another example might be appropriate here. Let's assume that the non-objective artist wants to depict a gay mood. In such a case, bright, cheerful colors would be appropriate. The line quality could also be light and springy, rather than dark and heavy. The balance might be informal and bouncy. The shapes could be happy rather than harsh. In effect, all the plastic elements would be designed to carry the feeling of gayness. On the other hand, if he had handled the form in the opposite way, feelings of sadness might be conveyed.

Beyond dealing with such basic feelings as gayness, sadness, love, and hate, a non-objective painting may convey feelings that have to do

with more complex concepts, such as music, architecture, the machine, organic life, and modern warfare. Usually, however, the non-objective painter will not have reality of any sort as a goal: he will simply make an abstraction, starting with nothing in mind and ending up with nothing in mind except the desire to make a successful design. This has been called abstraction for abstraction's sake. In the process, however, what emerges on the canvas is the individuality of the artist—that is, if the artist has found himself. We think of Piet Mondrian (Fig. 5), Robert Motherwell, Pierre Soulages, Alberto Magnelli, and Ben Nicholson as artists who have found themselves in this sense. They have become completely individual as far as their work is concerned. Such a quality goes beyond the style of a movement or a period; it is the style of a personality.

In spite of the fact that purely decorative art (a border design on a vase, for example) has been around for several thousand years, there is some validity to the argument that decorative art is inferior. People believe that it takes less skill and effort to make a painting that is purely decorative than to make one that has content and tells a story.

But what people believe is not true: making a good non-objective painting is a difficult task. The artist has nothing to fall back on but his ability to handle form. Without objects or symbols to relate to, the problem of good form becomes paramount.

The history of the development of non-objective art is a complex one. The break-through came with Cubism and, by the time the Futurists were on the scene, non-objective art had arrived. In the early days, the movement took two major directions: one growing out of Cubism and Futurism; the other stemming from the desire to work non-objectively.

As an illustration of the first direction, Piet Mondrian started out as an Impressionist. In the process of painting many landscapes with trees and buildings, he began to paint the trees and buildings more and more abstractly by leaving out more and more details. Eventually subject matter disappeared altogether: he had reached the purely abstract stage (Fig. 5).

Illustrative of the second direction is the career of Vasily Kandinsky who, as one of his many experiments, set out deliberately in 1910 to make a purely abstract painting. At the same time he wrote a basic book on Abstract Art. He called his paintings "Improvisations," and from the date they were exhibited, non-objective art has grown at an ever increasing rate.

In the work of Kandinsky and Mondrian, two distinct stylistic approaches can be seen. In Mondrian's purely abstract stage of development, we see a concise, linear, geometric approach. This style is commonly referred to as *hard edge*. With Kandinsky, we often see soft, free-flowing bio-morphic shapes (Fig. 65). This style, the opposite of *hard edge*, may

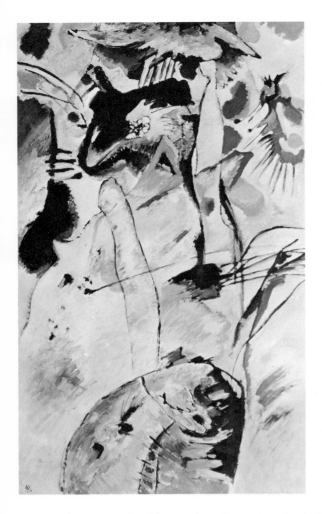

65. Wassily Kandinsky. *Composition (3)*. 1914. Oil on canvas, 64 × 36¼". Collection, The Museum of Modern Art, New York (Mrs. Simon Guggenheim Fund)

be equated with a painterly approach: it is more spontaneous, intuitive, and direct; the feel and texture of the paint are more in evidence. Kandinsky often worked with *hard-edge* shapes as well as bio-morphic shapes, using each for a particular purpose. Each style *empathically* evokes feelings that are quite separate and distinct. *Hard-edge* painting is formal, precise and machine-like in feeling; the painterly approach is informal, free, and organic in feeling.

Non-objective painting gained momentum in the twenties in France, Germany, and Holland, through the work of such artists as Mondrian, Arp, Kadinsky, Klee, Schwitters and van Doesburg. In America during the thirties, a few significant artists, such as Stanton MacDonald Wright and Charles Demuth, worked non-objectively. But there was little popular interest in Non-objective Art in America prior to World War II. With the arrival of Mondrian in New York during the war and with the gradual emergence of some of the pupils of Hans Hofmann, American interest in this style of painting gained momentum.

Abstract Expressionism

Although it was generally similar to the non-objective style of painting that had originated in Europe, the American brand was given the new name, Abstract Expressionism, to distinguish it as *action painting*. In this style what impresses the spectator, above all, is the feeling of the *act of making the painting*. For example, in a Jackson Pollock (Fig. 4), we can feel how the artist poured the paint from the can onto the canvas and how he moved about in the process. With Franz Kline, we feel the slosh of the brush—the energy of the brush-stroke as it sweeps across the canvas—we feel the bodily action of the painter himself. With Hans Hofmann, we experience an energy sensation he describes as the "pushing" and "pulling" of visual forces within the painting. One shape and one color is played against another, creating a feeling of tension and movement.

It would not be completely honest to say that the work of such European abstractionists as Kandinsky, Delaunay, Léger and Klee is completely devoid of action. Nevertheless, the new American style was one that might be described as a style of "bigger action." Paint was slapped and sloshed on larger canvases with a great deal more vigor. It was less smooth, less controlled, and more loose, accidental, spontaneous, and intuitive.

Abstract Expressionism was the prevailing style of painting during the fifties, not only in this country but throughout the world. Thousands and thousands of young artists worked only in this way, but few of them matched the strong individual statements of the original innovators in the field.

66. Robert Motherwell. *The Voyage*. 1949. Oil and tempera on paper mounted on composition board, 48 × 94". Collection, The Museum of Modern Art, New York (Gift of Mrs. John D. Rockefeller, 3rd)

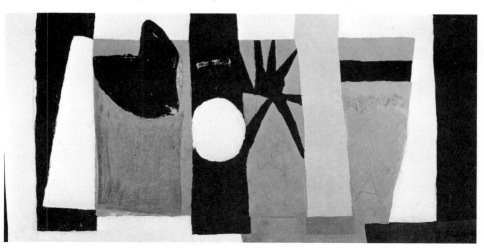

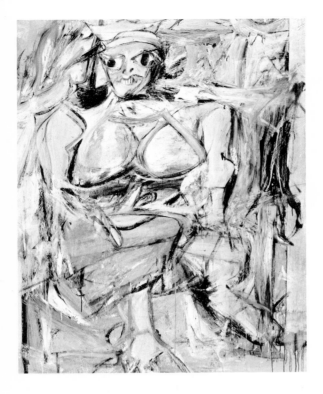

67. Willem de Kooning. Woman, I. 1950-52. Oil on canvas, 75⅞ × 58″. Collection, The Museum of Modern Art, New York (Purchase)

In addition to the Abstract Expressionists already mentioned, other pioneers in the movement deserve consideration. Robert Motherwell (Fig. 66) and James Brooks developed their highly individual styles slowly and patiently over the years. In their work we see order and consistency of form. Their statements are strong and well-founded. The work of Gottlieb and Baziotes speaks of primitive impulses and totemic imagery. The work of Tomlin and Tobey speaks of the calligraphy of the Atomic Age. Finally, in terms of feeling, de Kooning's work is in the tradition of Bosch, Grünewald, and Goya. His work with the brush stems from raw impulses, violent eruptions and charged emotion. In his scathing series on women, DeKooning continued to function as an action painter, but by returning to content he moved into another category—that of twentieth-century figurative art (Fig. 67).

Abstract Expressionism revitalized American figurative painting in the late fifties, especially in California under the leadership of Park, Wonner, Bischoff, and Diebenkorn. The freedom of Abstract Expressionism suggested to these artists an approach to the figure that was an extension of the earlier painterly approach of Vuillard, Kokoschka, and Henri.

The big city galleries were selling Abstract Expressionist paintings to the avant-garde and the new rich under boom conditions in the late fifties and early sixties. Too many of these customers were buying art not out of love but as an investment. For reasons mostly of a speculative

nature, the bottom dropped out of the market. To fill the gap there were two counter-currents: Op and Pop.

Op Art

Op Art (short for Optical Art) is another brand of non-objective art. It is the antithesis of Abstract Expressionism, however, inasmuch as it is *hard-edge* and not *painterly*. It moves into the realm of science, optics, and illusional effects, and is not unrelated to some of the earlier shape and color experiments of Josef Albers, though more "eye-dazzling." Some of the pioneers of Op are Victor Vasarely, Richard Anuskiewicz, and Bridget Riley.

Pop Art

This movement got its name from a now famous collage made by Richard Hamilton in England in 1956. He pasted together from photographs the following living-room scene: A narcissistically posed weight-lifter holding a giant lollypop; a nude, glamour-girl mate; framed on the wall a large comic-book cover; elsewhere, a tape recorder, a canned ham, a T.V. set, an electric vacuum sweeper, and a lampshade with a large Ford emblem on it. The collage was formless, cluttered, and poorly composed; it was an artifact, not a work of art. If anything, like Dada, it was anti-art. But, in terms of content, it was a dead-pan debunking of Anglo-American culture.

Soon to follow were Roy Lichtenstein and Mel Ramos with their oversize comic book paintings (Fig. 68). Almost at the same time, Ed Ruscha made a painting of the famous Twentieth Century Fox trade mark in a slick commercial technique reminiscent of the Spearmint Gum advertisements of the past three decades. He followed this with a similarly styled and arranged painting of a modern filling station. Andy Warhol, using the traditional commercial billboard "posterizing" style, painted glamour girls; Jasper Johns duplicated in bronze a coffee-can containing artist's brushes; and Wayne Thiebaud painted pictures of pastry and gum ball machines. Naturally, the press was aroused, not to mention the "museum boys," as Thomas Benton refers to them. In essence, Pop Art was given the million-dollar publicity treatment. So launched, it was possibly the most controversial movement in the history of art.

Pop Art speaks of our consumer society, of the new hot-rod world and the just-born-yesterday culture. Like Dada, it is anti-art. Its mood is negativistic. With few exceptions, its commercially derived forms do not enhance, and are not painterly.

Wayne Thiebaud is such an exception, and, in a certain sense, his work is not truly Pop. First, Thiebaud is painterly. Second, his comments

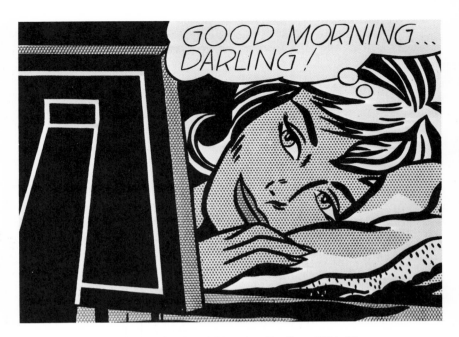

68. Roy Lichtenstein. *Good Morning Darling*. 1964. Magna on canvas. Collection, the artist

69. Wayne Thiebaud. *Girl in White Boots*. 1965. Oil on canvas, 6′ × 5′. Collection, Mr. and Mrs. Edwin Sabol, Villanova, Pa.

70. Jack Levine. *Welcome Home*. 1946. Oil on canvas, 40 × 60″.
Courtesy of The Brooklyn Museum

71. Auguste Rodin. *The Kiss*.
1886-98. Marble, over lifesize.
Rodin Museum, Paris

are critical, but often contain a sense of pathos—something not character-
istic of Pop (Fig. 69). Thiebaud may be closer to the tradition of such
strong-hearted American social realists as William Gropper and Jack
Levine (Fig. 70).

Unfortunately, there is an additional aspect of Pop that must be
considered in any honest overview. The work of the extremists in the
movement does not just border on the erotic, it is often bitterly and
sadistically pornographic. The avant-garde admirers of Pornographic Pop
consider such work to be profound and thus respectable. They are quick
to equate it with the new found freedom in literature and the theater.
Be that as it may, these formless and life-negative visual statements are
far removed from the earthy and life-affirmative statements about sex-
uality made by such artists as Breughel, Rembrandt, Rodin (Fig. 71),
Gauguin and Chagall, not to mention the searching pathos of Van Gogh
and Lautrec.

A Comparison of Styles of Painting

IMPRESSIONISM (Subjects: changing surfaces affected by light, such
as fluttering leaves, water, wind and sun, grass, smoke, fog.)

Main Characteristics:

1. Simplification of form
2. Texture and heavily painted surfaces
3. Generalization of objects
4. Broken color

Representative Artists: Monet, Renoir, Degas, Pissarro, Seurat.

EXPRESSIONISM (Origins in Nordic culture, Gothic pathos, spiritual
disturbance, tragic mode, social stress.)

Main Characteristics:

1. Intense color, expressive line
2. Monumental form, psychological force
3. Subjective, personal, emotional, mystical

Representative Artists: Van Gogh, Soutine, Nolde, Munch, Rouault,
Shahn, Weber, Rattner, Tamayo.

SURREALISM (Modern origins in Dada and Nihilism following World
War I.)

Main Characteristics:

1. Pure psychic automatism (thought free from control of reason)

2. Dream association, the impossible, the near possible, the fantastic, the grotesque
3. Chance, hallucination, psychic states
4. Intuitive development of impulses furnished by the unconscious

Representative Artists: Forerunners: Bosch, Breughel, Blake, Goya, Allston, Ryder; Contemporary: Dali, Klee, Miró, Ernst de Chirico, Tanguy, Berman, Chagall.

CUBISM (Invented by Braque and Picasso. Influenced by oriental painting, African sculpture, and Cézanne's composition. Equated with 20th century relativistic science and philosophy. Reaction against the rigid Renaissance forms of perspective, arbitrary modeling, and color.)

Main Characteristics:

1. Flat or decorative space
2. Multiple viewpoint, multiple perspective
3. Movement by repetition
4. Interpenetration of forms
5. Illusions of transparency

Representative Artists: Braque, Picasso, Gris, Feininger, Léger, Delaunay.

NON-OBJECTIVE ART (also) PURE ABSTRACTION, ABSTRACT EXPRESSIONISM, and OP

Main Characteristics:

1. Artist influenced by non-objective things in nature
2. Emphasis on basic visual elements: line, shape, color
3. Unique interests of painter—result: wide variety of styles: geometric, free-forms, action painting, optical effects
4. Applications to industrial design, fashion design, etc.

Representative Artists: Kandinsky, Mondrian, Pollock, Motherwell, Albers, Vasarely, Anuskiewicz.

POP ART (Subjects: Popular culture, the American scene.)

Main Characteristics:

1. Photographically slick rendering
2. Three-dimensional as well as flat space
3. Emphasis on comic book, billboard, and commercial art

Representative Artists: Lichtenstein, Ramos, Ruscha, Johns, Warhol.

CHAPTER FOURTEEN

Sculpture

THE UNIQUENESS OF SCULPTURE

The most obvious differences between painting and sculpture are those of materials and methods. In the one medium the artist limits himself to a two-dimensional surface, in the other, he is committed to working in three dimensions. In contrast to the traditional paint, brush, and canvas of the painter, the sculptor—the modern sculptor especially—works with a wide range of materials: he carves in stone and wood; models in clay; casts in plaster and bronze; welds in iron, steel, and aluminum; and forms in such new materials as laminated wood and plastic. Besides the completely different problems of craftsmanship, the sculptor is confronted with a different psychological situation.

While a painting is in process the painter is free to capitalize on sudden intuition: discoveries and changes can be made on the spot. On the other hand, sudden improvisations in stone or wood can lead to disaster. As a consequence, the sculptor cannot work as rapidly or as spontaneously as the painter. He must approach his work in a slow and reasonable way. Because, by its very nature, sculpture calls for patience and restraint, the approach of the sculptor is characterized as being deliberate. As a person, Michelangelo had a fiery temper, but as a sculptor his self-discipline has been unmatched.

When Michelangelo said that there is as much difference between painting and sculpture as between shadow and truth, he wanted to convey to the layman some sense of the sculptor's commitment to the medium. Of course, from the over-all standpoint of art, the one is no more noble than the other. Yet, since, in sculpture, changes in style and technique

usually come about more gradually, there is often more of a sense of continuity. And because the materials are more durable, there is also more of a feeling of permanence.

In regard to similarities, modern sculpture parallels modern painting. It is non-functional and non-utilitarian. Occasionally, sculpture is integrated with architecture, but, generally a modern piece of sculpture, like a modern painting, is viewed as a thing in itself. It stands alone. Moreover, where we find a major movement in painting, such as Cubism or Surrealism, we will find it also in sculpture (the same is true of the past). This brings up two points that we should like to clarify at this stage.

First, because the mediums are separate it does not necessarily follow that they differ widely in style—within the over-all style of a period or

72. *Menkure and His Queen,* from Giza. c. 2500 B.C. Slate, height 56". Museum of Fine Arts, Boston

73. *Standing Youth (Kouros).* c. 600 B.C. Marble, height 6′ 1½". The Metropolitan Museum of Art, New York (Fletcher Fund, 1932)

civilization. When we think of the Egyptian, Renaissance, Baroque, and Rococo styles, we do not think in terms of a separation between painting and sculpture. Sometimes, however, the creative innovations in one or the other may be said to be in the lead or to predominate.

Although Egyptian sculpture was massive and monumental, because of the surface treatment, low relief was emphasized. Consequently, Egyptian sculpture is often described as linear. The linear emphasis in the free-standing carving of *Menkure and His Queen* (Fig. 72) becomes obvious when we compare it with the relief carving of *Hesire* (Fig. 27). Thus, the drawing conventions of the Egyptians were imposed upon their sculpture.

On the other hand, when we think of the Greeks as artists, we think mainly of their accomplishments as sculptors. The Greek period was one of rapid change and development in sculpture. The dramatic change in style of Greek sculpture, that took place within a century, was based on a completely new understanding of human anatomy and on three-dimensional space. The static *Standing Youth,* or *Kouros* (Fig. 73) of the Archaic period is a far cry from what was to follow—such as the bronze figure of *Poseidon* (Fig. 74)—during the Early Classic period.

With the fall of the Roman Empire, sculpture all but disappeared as an art form. It re-emerged gradually during the Dark Ages, and, by the time Romanesque architecture gave way to Gothic, again reigned supreme. Yet, while we think of the art of the Gothic period primarily in terms of architecture and sculpture, drawing had its influence: the linear surface treatment in Gothic sculpture was derived in part from the drawing style of the illuminated manuscripts of the time. Notice the rhythmic and

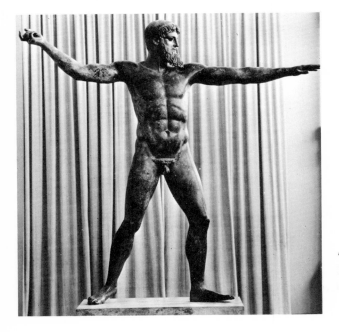

74. *Poseidon.* c. 460-450 B.C. Bronze, 82″. National Museum, Athens

linear treatment of the folds in the garments on the figures from the West Portal at Chartres (Fig. 16).

Painting was revivified during the Renaissance and has remained the arbiter of art forms until most recently. The sculpture of the Renaissance and Baroque periods, with the exception of the work of Michelangelo, was pictorial. That is, it duplicated in three-dimensional form the more illusional and fluid effects of contemporary painting. This trend was carried to extremes, especially during the Baroque period. Had sculptors such as Bernini considered tactile values instead of painterly ones, the sculpture of the past three centuries might have been more sculptural (Fig. 57).

Beginning with Rodin, sculpture has been regaining lost status. Although modern sculptors have been strongly influenced by Cubism, Surrealism, and Non-Objective painting, they, in turn, have made contributions to these styles that are uniquely sculptural. The surrealistic effects of Henry Moore, for example, are quite distinct from those of pictorial surrealism (Fig. 19).

This brings us to the second point. Although certain limitations are imposed by the medium and materials used by the artist, in the case of artists who have found their own personal voice, their style prevails over any "style" imposed by the medium or the materials. For example, the drawing style of Henry Moore is in keeping with his sculptural style. And his sculptural style in wood is like his style in stone or metal—despite the different qualities of these materials. Similarly, the drawings of Lachaise and Dubuffet are just as much a part of their personalities as is their sculpture. Picasso can work expressionistically or cubistically in either medium, yet, his expressionistic sculpture resembles his expressionistic drawings just as his cubist sculpture resembles his cubist paintings. Finally, in spite of his habit of calling himself a sculptor and not a painter, Michelangelo is not revered for his carvings alone. When we compare his painting with his sculpture, it is the style of Michelangelo that moves us, regardless of the medium.

Remember, when we measure the worth of the artist, the medium, be it stone or paint, is not the determining factor. On the other hand, when we refer to periods, it may be said that one period favors the sculptor and another, the painter.

Keeping the idea of similarities and differences in mind, we need to consider sculpture from the standpoint of the spectator. Just as the artist is confronted with different problems of interaction due to differences in medium and materials, so too is the spectator.

EXPERIENCING SCULPTURE

As with all works of art, we experience sculpture through all our senses, *but mainly through our hands*. As they work, most sculptors con-

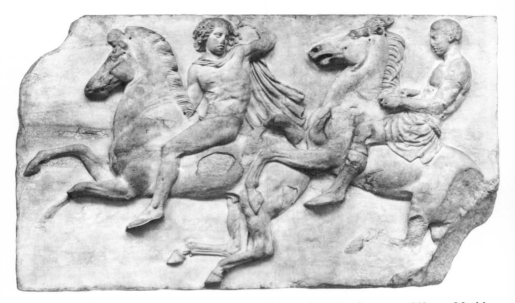

75. *Horsemen*, from the west frieze of the Parthenon. c. 440 B.C. Marble, height 43″. British Museum, London

76. Michelangelo. *Moses.* c. 1513-15. Marble, height 8′ 4″. S. Pietro in Vincoli, Rome

stantly move their hands over the surface of the piece they are working on. In doing so they are interacting with the work not just visually but also in terms of tactile sensations. Our interaction with sculpture in terms of tactile values has to do with our capacity to respond to: shapes, both round and angular; edges, both sharp and full; and textures, both smooth and rough.

It may also be said that we respond to sculpture in terms of its volume—its entity in the three-dimensional sense. Our interaction with the sculptural object is based on our awareness of it as not only occupying but also utilizing three-dimensional space. We respond to it not just in terms of its outside shape, mass or surface, but also in terms of the space it contains, the empty space that exists between the various surfaces. Sculpture is not something we only look at—we look into, around, and through it as well.

In considering how to interact with a piece of sculpture, such as Henry Moore's *Recumbent Figure* (Fig. 19), from the standpoint of full sensory aliveness, the answer might be found by asking the following question: How would a small boy experience the work as he explores it by climbing over, into, and through it?

Another factor important to experiencing sculpture is the kinetic factor. The term *kinetic* pertains to movement, and in sculpture, movement may be experienced in several ways. When we look at the figures in panathenaic procession in low-relief on the *Parthenon frieze* (Fig. 75), we become aware of movement primarily because of the arrangement, the way in which the figures are organized and designed linearly. The same effect is apparent in the *Discobolus* (Fig. 10). Although this sculpture is in the round, it was really designed to be seen from the front where the linear quality is strong. The movement we feel in the *Discobolus* is often described as quiet movement. Restraint, relaxation, and harmony are characteristic of the Greek style.

We respond to movement in a different way in the works of Michelangelo. In his famous figure of *Moses,* for example, the movement is anticipated (Fig. 76). The figure is often described as expressing the feeling that Moses is about to move forward and rise. Thus, we empathically sense the forcefulness, power, and leadership of Moses. In most of Michelangelo's sculpture the feeling of movement is usually conveyed by the way in which he creates tension between one part and another. Often in his figures, legs, arms, and torso are entwined and appear about to uncoil like a spring. This same effect is stressed non-objectively in Duchamp-Villon's *The Great Horse* (Fig. 77).

Movement may be conveyed empathically through the abstract shape alone, as in the case of Brancusi's *Fish* (Fig. 78). Many other modern sculptors, such as Moore, Lipchitz, Gonzales, Laurens, Boccioni, Pevsner, and Moholy-Nagy concern themselves with abstract shapes that empathically evoke kinetic sensations.

77. Raymond Duchamp-Villon. *The Great Horse*. 1914. Bronze, height 39⅜″. The Art Institute of Chicago (Gift of Miss Margaret Fisher)

78. Constantin Brancusi. *Fish*. 1930. Marble. The Museum of Modern Art, New York (Acquired through the Lillie P. Bliss Bequest)

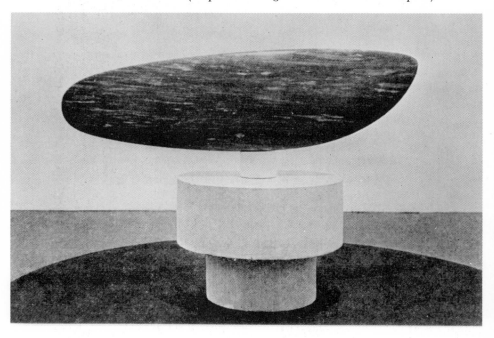

Finally, with the famous *mobiles* of Alexander Calder, the sculpture itself moves. Rightfully, the kind of sculpture that has moving parts is also referred to as kinetic sculpture. Remember, as we pointed out in chapter six, our capacity to move about may be equated with our kinetic awareness in art. Along with sight, touch, and breathing, it is one of the important perceptual tools in the evaluation of a work of art.

THE METHODS OF SCULPTURE

The two traditional methods of sculpture are carving and modeling. Michelangelo carved his *Pietà,* his *David,* and his *Moses* out of marble. Rodin first modeled his figures such as *The Thinker* in clay or wax and then had them cast in bronze.

In carving, the process is subtractive: The sculptor chisels or carves away at the block of stone or wood. Thus, Michelangelo speaks of the figure being hidden in the block of marble, of the image revealing itself as the carving progresses and of the sculptor's task being to *free* the figure from the stone. Much of Michelangelo's work gives visual verification of this concept. In contrast to his figure of *David,* for instance, his figure

79. Michelangelo. *St. Matthew.* 1506. Marble, height 8′ 11″. Academy, Florence

of *Saint Matthew* (Fig. 79) is left in an unfinished state and the figure appears to be actually fighting to free itself from the stone. As we study such pieces, as well as the *Pietà Rondanini* (Fig. 35), we can see how Michelangelo carved into the original stone block, gradually and with deliberation. The physical resistance of the stone, incidentally, was something that Michelangelo always found challenging.

In carving, most sculptors usually try to retain some sense of the original block. This gives the spectator an opportunity to realize more fully the compositional aspects of the work. He becomes not only aware of the physical resistance offered by the stone but he can also appreciate how the sculptor has composed within the limitations set by the shape of the original block. With his figure of *David,* comparatively most finished, Michelangelo left parts of the top of the head as well as parts of the back untouched to let the observer know exactly where the original edges of the marble were.

In modeling, the process is additive: The sculptor builds, using malleable materials such as clay or wax. After building the form through modeling, the work is usually then fired or cast. For example, clay, if prepared properly, may be fired. Such sculpture is called terra-cotta.

Casting may be done in plaster or in bronze. If it is plaster, a mold is made, the original clay piece is removed, and plaster is poured into the mold. The mold, in turn, is removed, revealing the piece cast in plaster. Casting in bronze is somewhat similar but considerably more complicated and need not concern us here. The traditional method for bronze casting is called the *Lost Wax* method.

Unlike direct carving, in the additive method the artist can change and re-work. He can introduce surface detail more easily and he can also work with more fluidity, especially if he is casting in bronze. For example, Rodin was so expert in capturing movement and surface detail that when he first exhibited his figure *The Age of Bronze,* he was accused of making his mold from a live model.

Rodin took further advantage of the flexibilty offered by the additive method by sometimes leaving accidental effects caused by his fingers, or tools, or the cloth the clay models were wrapped in to keep them from cracking. In one instance, early in his career, as he was working on his now world famous piece, *The Man with the Broken Nose* (Fig. 80), he capitalized on an accident in which part of the back of the head had cracked away. When the finished piece was first exhibited, it was rejected (as were Impressionist paintings) because of its sketchiness and lack of finish. As an artist, Rodin was never compelled to finish things down. Just as Rembrandt worked and re-worked with paint, so too did Rodin work with clay. His work was full of life in this sense; his modeling was direct and deliberate but never labored.

A third, and now major, sculptural method, stemming from industrial techniques of the twentieth century, is welding. This method is

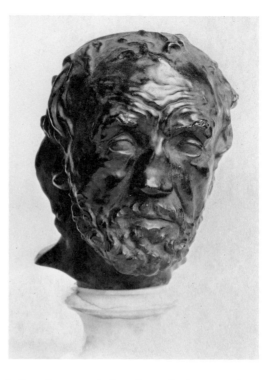

80. Auguste Rodin. *The Man with the Broken Nose.* 1864. Bronze, height 9½". Rodin Museum, Philadelphia Museum of Art

related to the additive method. But, because it involves piecing together, as well as the use of different metals, it has its own characteristics. In welding, scrap metal may be used, or patterns may be made and pieces cut from sheet steel. The pieces are joined together by welding with an oxyacetylene torch. Sometimes various metals, such as copper, brass, and steel are combined, or sometimes one metal is brazed with another.

Welded sculpture has become popular since the Second World War for several reasons. Stone and wood suitable for sculpture are becoming more scarce and expensive. Casting in bronze is also expensive. On the other hand, scrap metal is readily available and easy to work with, provided the proper shop equipment is used. But even more important, metal—assembled, welded, hammered, melted, pressed, painted, polished, and patinated—seems to incorporate the feelings of not just the Machine Age but of the Atomic Age. Welding with metal is, today, the most popular method with sculptors. Some of the most outstanding sculptors working with welded metal are Americans, such as Theodore Roszak, Seymore Lipton (Fig. 81), and David Smith (Fig. 82).

APPROACHES TO SCULPTURAL FORM

As with all art, development in sculptural techniques has not been a matter of progress. In terms of quality, the sculpture of Egypt stands up well against the sculpture of our time or any other age. However, histori-

81. Seymour Lipton. *Sorcerer,* 1957. Nickel-silver on monel metal, height 60¾″. © Whitney Museum of American Art (Gift of the Friends of the Whitney Museum of American Art)

82. David Smith. *Twenty-four Greek Ys.* 1950. Forged steel, painted, 42¾″ high. Collection, The Museum of Modern Art, New York (Blanchette Rockefeller Fund)

cally, in terms of treatment of sculptural form, successive, evolutional stages of development can be found.

Except for amulets, small votive pieces and the like, the sculpture of the earliest civilizations was massive and monumental. The shapes that were devised were, more or less, simply *blocked out. The Great Sphinx of Egypt* (Fig. 83), as well as the giant heads of the early Easter Island culture (Fig. 30), were little more than extensions of early monolithic forms such as those found at Stonehenge (Fig. 84). This same emphasis on bulk is apparent in the Menkure figures (Fig. 72), where the suggestion of three-dimensional form is very subtle and where a linear treatment of the surface prevails. Emphasis on the massive and the blocked-out can occasionally be found in the work of such modern sculptors as Brancusi, Modigliani, Baskin, and Moore.

By the time of the Greeks, sculpture was becoming more a matter of *modeling.* In the Greek Kouros figures (Fig. 73), variety is given to the shapes: the shapes are more open and more of a feeling of three-dimensional space is present. The sculpture of Athens during the Golden Age and of the Hellenistic period, with such familiar works as *Poseidon* (Fig. 74), *Aphrodite, Nike of Samothrace* (Winged Victory), the *Venus de Milo* and *The Laocoön,* exemplifies three-dimensional modeling in its most traditional sense. During the Renaissance the *modeling* approach reached maturity in the works of Michelangelo. Among the highly indi-

126

83. *The Great Sphinx*. c. 2530
B.C. Height 65'. Giza.

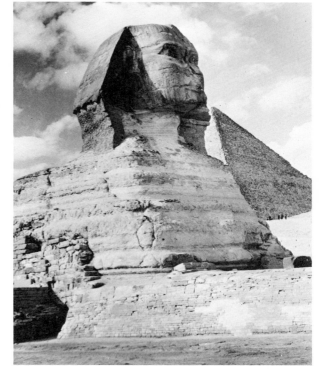

84. Stonehenge. c. 1800-1400 B.C. Diameter of circle 97', height of
stones above ground 13½'. Salisbury Plain, Whiltshire, England

85. Umberto Boccioni. *Unique Forms of Continuity in Space.* 1913. Bronze, height 43½". The Museum of Modern Art, New York (Acquired through the Lillie P. Bliss Bequest)

86. Antoine Pevsner. *Torso.* 1924-26. Plastic and copper, height 29½". The Museum of Modern Art, New York (Katherine S. Dreier Bequest)

vidual modern sculptors who use the traditional modeling approach are: Rodin, Matisse, Maillol, Lehmbruck, Laurens, and Marini.

From the Renaissance to the twentieth century the *modeling* approach prevailed. But, due to the "new ways of seeing" first introduced by the Post-Impressionist and Cubist painters, completely new approaches to sculptural form followed. The Futurist, Boccioni, introduced a new

87. Richard Lippold. *Variation within a Sphere, No. 10: The Sun* (with plain background). Gold-filled wire, 22 K, height 11', width 22', diameter 5½' (approx.). The Metropolitan Museum of Art, New York (Fletcher Fund, 1956)

approach to motion in sculptural form with his *Unique Forms of Continuity in Space* (Fig. 85). The Russian Constructivists, such as Tatlin, Malevich, and Rodchenko introduced the idea of assembling all sorts of miscellaneous subjects in three-dimensional space arrangements. Constructivist sculpture has been carried further by such artists as Pevsner, Gabo, and Moholy-Nagy. Pevsner works with metals and plastics, creating forms having deep hollows and sunken spaces (Fig. 86). Gabo and Moholy-Nagy "modulate" sculptural form by twisting and turning plastics into organic-like shapes. Henry Moore's sculptural forms may be described as perforated or bored-through. Calder creates kinetic or moving forms with his mobiles. Lippold's forms are suspended (Fig. 87). Giacometti's and Nevelson's are sometimes "caged" or "boxed." John Chamberlain makes constructions out of smashed automobile bodies. Eduardo Paolozzi makes constructions called "idols" out of computer machine parts. And Frank Gallo makes manikin-like figures, in the Pop Art tradition, out of Fiberglas.

Like the contemporary painter, the contemporary sculptor has probed virtually every subject available to the artist. And, by nature of the Machine Age, the sculptor has been able to experiment with materials to an even greater extent than the painter. However, as with painting, the measure of quality in many of these experiments is yet to be determined. As critics, such as Herbert Read and Michel Seuphor suggest: the next phase will be, most likely, a phase of settling down, a phase of assimilation and consolidation. In modern painting and in sculpture, we are passing from a pioneering stage to a stage of maturation.

CHAPTER FIFTEEN

Architecture

THE RELATIONSHIP BETWEEN ART AND ARCHITECTURE

Up to now, we have been discussing Fine Art, namely painting and sculpture. We have concerned ourselves with the problems of looking at and understanding art. As we begin this chapter on architecture, several questions arise: What does architecture have to do with art, what is the connection? Isn't architecture more a matter of constructing and engineering than art? Doesn't architecture serve a utilitarian or functional purpose since it has to do with the building of homes, churches, offices, factories, and bridges? And, by contrast, isn't art considered to be non-utilitarian, serving no *useful* purpose? Isn't a work of art a thing in itself, something to be enjoyed for its own sake? Do not works of art stand apart from architectural factors? Are not the Egyptian tomb paintings appreciated apart from the tomb, the Greek friezes apart from the temple, and Michelangelo's Sistine frescos apart from the Sistine Chapel?

While it is generally true that a work of art is non-utilitarian and that it stands alone as a thing in itself, it is also true that a building can be more than just a building or a bridge more than just a bridge. Anyone who takes the time to look can see that Frank Lloyd Wright's *Bear Run House* is more than a house—it is a work of art (Fig. 88), and the familiar Golden Gate bridge in San Francisco is far more than just good architectural engineering. It, too, is a work of art. As with all meaningful works of art, both inform the mind and delight the eye. Both symbolize and express the modern age at its best. Both enhance. The Frank Lloyd Wright house is in organic harmony with the natural environment. Thus,

88. Frank Lloyd Wright. Kaufmann House. 1936-39. Bear Run Pennsylvania

through the architectural design, the occupant, Modern Man, is brought back into a comfortable but functional relationship with nature. The Golden Gate bridge is vital to the world of everyday commerce and metropolitan living.

Good architecture goes beyond mere function. Like good art, it expresses an inner truth, an inner meaning; it says something. In the well-designed home, church, school, office, or factory, we are, in turn, more contented, pious, studious, efficient, or productive. Further, in the well-designed city, we are bound to be happier citizens.

Design distinguishes the work of an architect from that of a mere builder and design makes architecture an art. Like the artist, the architect orders and arranges shapes and space. He deals with planes, volumes, masses, textures, and color; he concerns himself with problems of balance, proportion, harmony, rhythm, and so on. Like the artist, he must be aware of the empathic as well as the symbolic aspects of mass or shape, as in the case of the monumental and stable Egyptian pyramid or the skeletal, light, and soaring Gothic Cathedral. Of course, as a designer, the architect must deal with engineering factors. He must know the structural limitations of his materials. He must also know how to use appropriately such space-spanning devices as the post and the slab (Fig. 2); the arch (Fig. 89); the dome (Fig. 90); and the cantilever (Fig. 88).

Architecture has often been referred to as the Mother of the Arts. In this regard, it was not unusual in earlier civilizations for art and architecture to function almost as one. This was especially true during the Egyptian, Greek, and Gothic periods, where the two were mutually enhancing and in harmony. Generally, from the Renaissance until the twentieth-century, the relationship was less successful. While art today is far from being at the service of architecture, as in the case of the over-

powering Egyptian temple or the dominating Gothic Cathedral, Modern Art and Modern Architecture are not in conflict. In spirit, both have much in common. Both mark a separation from the past. Both work with a new and creative rather than imitative vocabulary of form, shape, and symbol. Both visibly express and accommodate human life in a new multi-dimensional world.

There has been a great breakthrough with Modern Architecture. To appreciate the significance of this, it is necessary to know something of the role architecture played in the past. Before saying more about the new architecture, let us briefly characterize the old.

Egyptian Architecture

In Ancient Egypt, the houses of the common people and even the palaces of the rulers were unimpressive, semi-permanent structures made of adobe brick—of no significance from an architectural standpoint. Like the architecture of most early civilizations, Egyptian architecture was at the service of the gods. It was in the building of the tomb and the temple that Egyptians excelled. Both were monumental and distinctive, both were great engineering feats, and both emphasized mass and volume rather than space.

89. Pont du Gard, Nîmes. Early 1st century A.D.

90. *The Interior of the Pantheon*, painting by Giovanni Paolo Pannini. c. 1750. National Gallery of Art, Washington, D.C. (Kress Collection)

91. Three-aisled Hall of Thutmose III. c. 1470 B.C. Temple of Amen, Karnak

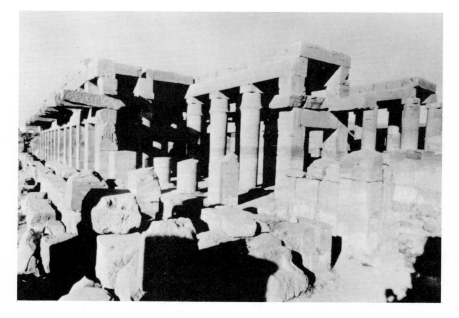

The first tombs were solid rectangular mounds of sand, wood, and sometimes stone called mastabas. The next development was the famous step pyramid of Zoser which consisted of six diminishing mastabas piled one on top of another. Evolving out of the more impressive step pyramid were the great pyramids of Giza. These had raking, or smooth side walls of stone. From the engineering standpoint, the pyramids were architectural marvels. Thousands of blocks of stone, each weighing as much as two and a half tons, were put together with great precision. The pyramids, of course, symbolize the religiously oriented Egyptian civilization.

Egyptian Temples were of column and slab construction (post and lintel). Significantly, the outer shapes of these columns were derived from natural forms, such as the papyrus and the lotus. Like the pyramids, the Egyptian temple was conceived in terms of great scale and mass (Fig. 91). They were meant to be mysterious and forbidding. Walls and columns were heavy, and by comparison, entranceways and doors were small. Access to the inner temple or sanctuary was gained through colonnaded courtyards, multi-aisled halls and dimly lit chambers. Only the priest-king rulers had the right of access.

GREEK ARCHITECTURE

Greek architecture was considerably more varied than Egyptian. Besides temples to their gods, the Greeks built market places, law courts, schools, and gymnasiums. Greek houses were far from sumptuous, and their cities were generally unplanned, rambling, and without adequate sanitation facilities.

The buildings on the Acropolis at Athens typify Greek architecture at its best. There, such temples as the Erechtheum and the Parthenon (Fig. 2) are of column and slab construction, with a gabled, or pitched roof. Compared to the Egyptian temple, the Greek temple is less devoted to what Herodotus describes as the silly nonsense of the after-life. The Greek temple is far less colossal; it is scaled to man. Yet, while it is more open and less secretive, it contains no great expanse of interior space. Achievement in this realm came with the Roman and Gothic builders. And unlike the Gothic Cathedral, the Greek temple does not soar; it is earthbound. Thus, it exemplifies the Greek attitude about life: naturalistic and humanistic rather than ascetic and mystic.

The Parthenon was the greatest architectural statement of the Greeks. It speaks of dignity, refinement, harmony, and balance. It is solid yet springing with life. To achieve this effect, the Doric columns swell slightly and lean inward slightly, and the distance between them varies. The platform upon which the columns rest curves slightly upward in the middle. The Parthenon was engineered, but it was also designed to please the eye and enhance the spirit.

92. The Basilica of Constantine, Rome. c. 310-320 A.D.

ROMAN ARCHITECTURE

In the early days of Rome the builders tended to copy Greek forms. But in the process of developing an empire, the Romans soon introduced forms of their own designed to accommodate the citizenry. They began to plan their cities. Streets were laid out in grid fashion and some provision was made for sanitation.

The Romans were great engineers. They took the simple concept of the arch and applied it inventively in many different ways. They lined arches up in rows and stacked them story-wise to build great aqueducts, bridges, and colosseums. They lengthened the arch in a tunnel-like fashion, to create barrel vaulting. By means of intersecting barrel vaults, well-lighted and vast interior spaces were created. Buildings, such as the Basilica of Constantine (Fig. 92), were based on such varied uses of the arch. In plan, the Roman Basilica has had a lasting influence on civic and church architecture.

The invention of concrete was another important Roman contribution. Such sturdy structures as the Colosseum and the Pantheon, with its great dome (Fig. 90), were built with concrete fill. Today, of course, we re-enforce concrete with steel.

Considering the technological limitations of the times, Roman buildings were exceedingly well constructed. However, unlike the more severe Greek architecture, Roman architecture tended to be sumptuous and ornate. Decorative excess was an unfortunate part of the grandeur that was Rome.

GOTHIC ARCHITECTURE

Following the collapse of the Roman Empire, architecture regressed in the West for several hundred years. With the building of Christian churches, it emerged again as an art during the Early Middle Ages. But,

ancient engineering solutions were applied in the development of what came to be called the Romanesque church. The floor plan of these churches was taken from the Roman basilica. The round arch and barrel vaulting were used, with the weight being distributed by thick and heavy side walls. There were few windows and the churches tended to be gloomy and fortress-like in appearance.

Later, in France, new and more enhancing forms were introduced by the builders of the Gothic cathedrals. The pointed arch, together with ribbed vaulting, provided a new freedom of construction. The weight of the ceiling was now supported by intersecting bands of thin stone webbing running across the ceiling and down, from side column to side column (Fig. 93). The tall and clustered columns were supported by flying buttresses on the outside of the cathedral.

With the weight being supported by ribbed caging, the side walls gave way to stained-glass windows. With this colored, gem-like lighting, the cathedral interior was transformed; it became celestial. Thus, with its stained glass, its soaring columns, and its sculpture, the Gothic cathedral became, to medieval man, a piece of heaven on earth. It truly symbolized the Age of Faith.

93. Nave (looking west), Chartres Cathedral. 1194-1220.

94. Filippo Brunelleschi and others. Pazzi Chapel. Begun 1430-33. Sta. Croce, Florence

95. Façade, S. Carlo alle Quattro Fontane. 1665-67

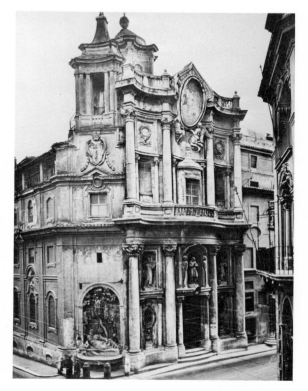

RENAISSANCE, BAROQUE, AND VICTORIAN ARCHITECTURE

During the Middle Ages the Greco-Roman civilization was all but forgotten except in Italy. There the ancient ruins were never completely destroyed; half buried, they reminded the Italians of past grandeur. The Florentine architect Brunelleschi set the tone of Renaissance architecture after going to Rome to study the ancient methods of construction and decoration. He revived all of the classical forms. In constructing his buildings, he re-introduced such things as the column, the pilaster (an artificial column), the pediment, the round arch, the rotunda (a round room), the dome, and the decorative embellishments of the Romans (Fig. 94). In spite of such an assorted package, Brunelleschi's buildings were not undignified since he also concerned himself with measure, order, and balance.

The architecture of the Late Renaissance and the Baroque period was not so well ordered. Everything became bigger and grander, but no new structural elements were introduced. Non-structural elements abounded; false pillars, false windows, false doors, and steps leading nowhere became commonplace. Balustrades (guard-rails) were placed around roofs where no one walked, cornices (shelf-like forms) were

96. John Nash. The Royal Pavilion, Brighton. 1815-18

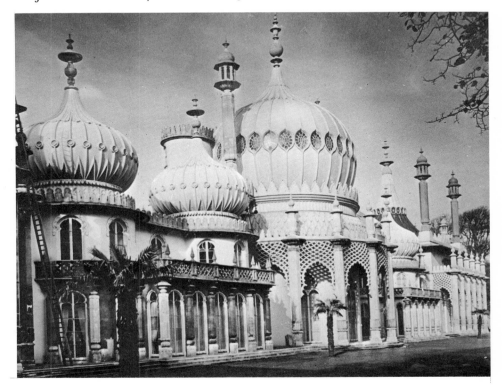

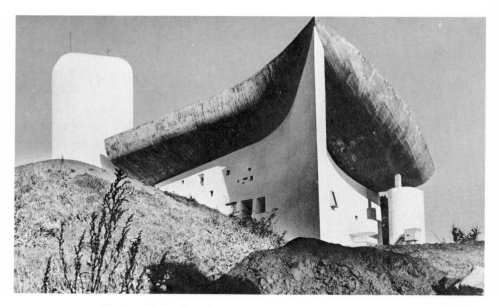

97. Le Corbusier. Notre-Dame-du-Haut, from the southeast. 1950-55. Ronchamp, France

98. Eric Saarinen. TWA Building. TWA photo by Ezra Stoller Assocs.

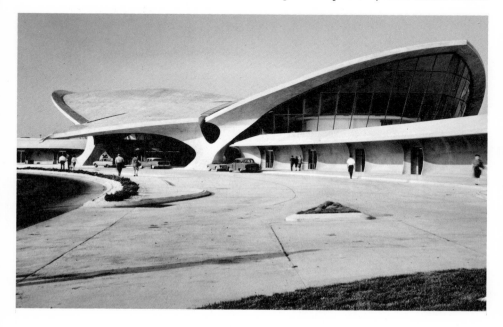

thrown-up wherever possible. Trimmings and embellishments, lacy and gilded, pressed on the eye (Fig. 95).

The pseudo-classical motifs and the magnificent filigree appealed to the devotees of antiquity and the bourgeoisie, but such things also put architecture in a rut. The policy of architectural revivals was established. It remained entrenched until the twentieth century and plagues us still.

During the last half of the eighteenth century, people began to tire of the sumptuous baroque and the slightly more delicate rococo. But instead of inventing new forms, architects chose again to revive old ones. There was a Roman revival, a Greek revival, a Gothic revival (Fig. 96), an Oriental revival, and so on. Many of our American buildings constructed in the 1800's were products of Greco-Roman revivals. Among the best were those designed by Thomas Jefferson; among the worst were those pseudo-Greco-Roman temples found in every town across the land. They served as court houses, post offices, and even homes. It was only yesterday, at the turn of the century, that some of our wealthiest citizens had the pleasure of living in Romanesque fortresses, Gothic castles, Spanish monasteries, and Arabian mosques. Modern architects, such as Frank Lloyd Wright, called a halt to this tradition of refurbishing, or what Wright referred to as, "a carnival of imitation."

Modern Architecture

Rather than speaking of its time and place, Renaissance, Baroque, and nineteenth-century architecture tended to imitate the past in one way or another. What is implicit in modern architecture is the idea that each age must live its own life. Modern architecture manifests this idea in two ways.

First, there is the idea of function. The Gothic cathedral was functional in its time and place. But today, to build a church only with small stone blocks, and to explain the faith only by means of stained-glass or sculptural picture-stories, would be absurd. In a contemporary church, such as Courbusier's Ronchamp church in France (Fig. 97), functional harmony is achieved by considering not only the purpose for which the building is to be used, but also its relationship to its environment—through the use of modern materials and construction methods (re-enforced concrete).

The idea that form follows function originated with the American architect Louis Sullivan, who designed some of our first modern skyscrapers. Functionalism, with the emphasis on engineering, has been furthered by such architects of the German Bauhaus school as Walter Gropius and Mies van der Rohe. Functionalism, with the emphasis on organic unity, has been furthered by Frank Lloyd Wright and his pupils.

Second, there is the idea of symbol. The Gothic cathedral was more than a shelter to worship in; it was a symbol of Medieval Christianity. The shape of the Ronchamp church is a form of symbolic expression in keeping with our time. Another building that is both functional and symbolic in shape is Eero Saarinen's TWA airport terminal building (Fig. 98). Also, symbolizing the new age are our great skyscrapers, and suspension bridges and our modern expressways. Further, the new planned-city of Brasilia in South America functions as a symbol of a new era in human living.

CHAPTER SIXTEEN

Art Today:
Our Universal Art Heritage

In bringing our discussion of art to conclusion, a summing up is called for. We need to know where we stand in art today and why. We need to consider the total picture, an over-view: our *universal* art heritage. By stepping out of the mainstream, by viewing the art of our immediate past and our own times from a distance, so to speak, a paradox becomes apparent: an historical sequence of universalization and individualization can be found.

First, considering the idea of universalization, man has for the first time, because of the camera and the printing press, an *over-view* of the world's art. Therefore, to talk of the artistic creation of the twentieth century in the specialized terms of a particular style, formula, or program, or through the eyes of a school or group, becomes an outmoded approach. In the world of modern art, the flourishing forms of Expressionism, Cubism, Surrealism, deliberate primitivism, Abstraction, Pop Art, and Op Art are felt immediately by all because of our new multi-communication media. And remember, most of the so-called modern movements in art are already half a century old. Cubism, Surrealism, and the like, have survived the time test. To argue their validity today, as the critics did at the turn of the century, is unreasonable.

The day of major departure, as it has been known in the past, is apparently over as well. It seems reasonable to assume that the art of the near future is not to be the art of a particular school. André Malraux's phrase, "Museum Without Walls," [1] suggests a new understanding: a

[1] Malraux, *The Voices of Silence.*

143

more universal interaction of world art. Never before in the history of the world have artistic legacies been so readily accessible to untold millions. From the stylization of the Egyptian muralists, to the force of the painters of the 1913 Armory Show (the first exhibition of abstract art in this country), to the creativity of modern abstractionists like Paul Klee, a process of artistic diffusion has taken place that has no equal in the past. The diverse characteristics of modern art, with directions resuscitated from the cultural energy of all the past, have crystalized into forms that are, in our culture, almost commonplace. The heritage of the past becomes an integral part of us because of its accessibility and the readiness of the modern artist to assimilate it and pass it on.

Universal Art becomes universal personality. Our resuscitation of this universal heritage has helped mature our concepts of the role of the artist to the point that his nationality is of little or no consequence. He is the first citizen of the world state that is to come, if we are to survive. This was not so in the past. Meissonier, whether we like it or not, is official nineteenth-century France and Thomas Hart Benton, twentieth-century mid-western American regionalist. But Cézanne is not necessarily *French* late nineteenth century or Klee, Swiss twentieth century. For these modern artists there are no national boundary lines; their statements take on a more universal quality (Fig. 19). There has been a process of universalization.

Our second point is that increased *individualization* is also an important characteristic of contemporary art. As Eric Fromm, the psychiatrist, has pointed out, modern man, being affected by the dynamic psychological processes operating within himself and within society, longs to function in a free way. In other words, modern man has a drive to be free. Contemporary artists, in their work, have the same drive. Artists, as never before, want to be free from binding styles, free to explore, free to say something new, to invent, to create (Fig. 77). To paint and sculpt in an individually free way is something demanded by the artist of our time. Of course, in this regard, the significant artist will be the one who gives evidence of a positive or responsible sense of freedom. Freedom without responsibility has no longer-lasting value in art than in any other human endeavor. Nevertheless, the primary reason for the popularity of contemporary art, with its multitude of innovations, is that it allows for enormous flexibility of expression. As such, it facilitates the artist's search for freedom of expression. In his *Dictionary of Abstract Art* Michel Seuphor expresses this well:

> . . . the idea of liberty. I cannot think of a more appropriate word to convey the fundamental characteristic of modern art as a whole. Not only does it define it according to its underlying psychological basis, but the word encloses and sums up all its visible manifestations.[1]

[1] Michel Seuphor, *Dictionary of Abstract Painting* (New York: Tudor Publishing Co., 1957), p. 12.

Universalization and individualization, as diametric as they may appear, are the key ideas behind modern art. This is the significance of our universal art heritage.

Index of Names

Index of Topics

Art, techniques in
 collage, 44
 counterchange, 44
 frottage, 44
 pointillism, 44
Artist, development of
 effect of past masters, 72
 personal style, 73
 stimuli for, 72
Artist, personality of
 creativity of, 68
 individuality of, 69-71
 stereotyped view of, 67
Artist, responsibility of, 13
Assyrian art movement, 29

Baroque, architecture of, 139-140
Baroque art, style of, 83
Beauty, concept of, in art, 29
"Bison with Turned Head," 47
Byzantine art, 29, 41; abstraction in, 78

Calligraphy, 6
Camera, use of, 17
Carving, process of, 123-124
Casting
 in bronze, 124
 in plaster, 124
Cézanne, Paul
 approach, 94
 color, use of, 95
 compositional manipulations of, 95
 Cubists, effect on, 94
 parallel brush stroke technique, 95
Chiaroscuro, technique of, 23
Collage, use of, 103
Color, Impressionist use of, 87
"Column of Trajan," 20
Constructivist sculpture, 130
Consumer art, 7
Contemporary art, individualization
 of, 144
Creative personality
 everyday behavior, 68
 individuality, 70
 introversion, 69
Cro-magnon man, 45-46
 artist, 47
Cubism, 29
 evolution of, 97-98
 "flatness" of, 95-96
 function of, 94
 influences of, 99
 techniques of, 97
Cubism, analytical, 97
Cubism, synthetic, 97-98

Dadaism
 kind of art, 101
 reasons for, 101
David, by Michelangelo, 4, 123
Der Blaue Reiter, 92
Design, basic principles of, 66
Die Brücke, 92
Discobolus, 17, 121

Egyptian architecture
 pyramids, 135
 religious aspects of, 133-135
 temples, 135
 tombs, 134
Egyptian art
 abstraction in, 78
 religious aspect of, 39-40
 style of, 20, 29
Egyptian sculpture, linear emphasis
 of, 118
Expressionism, 29
 color, use of, 91-92
 distortion in, 91
 origins of, 91
 qualities of, 90-91
 style of, 91-92
 texture of paint in, 92

Fauves
 color, use of, 92
 style of painting, 92
Functionalism, 141-142
Futurism, techniques of, 98

"Genre" style of art, 84
Gothic architecture
 religious aspect of, 136-137
 Romanesque churches, 137
Gothic sculpture, 118
Greco-Roman revival in architecture,
 141
Greek architecture, 135
Greek art
 beauty, 37
 form, 37
 philosophy of, 19
"Greek Experience," 9
Greek sculpture
 anatomy, based on, 118
 form of, 20
 style characteristics of, 121
Guernica, 11
 content of, 56
 feelings of, 56
 form of, 56

Hard-edge style, in art, 107

E. BURSA

EPIDINIUM

Rumen — many
Reticulum — particular type
true stomach — no protozoa